WATERCOLOUR FLOWERS

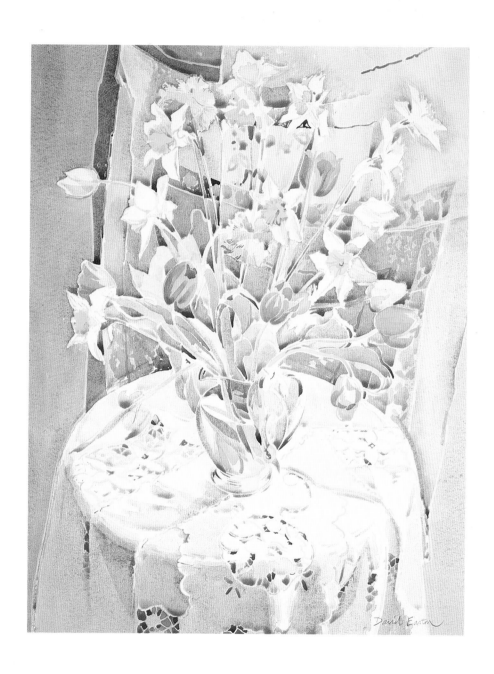

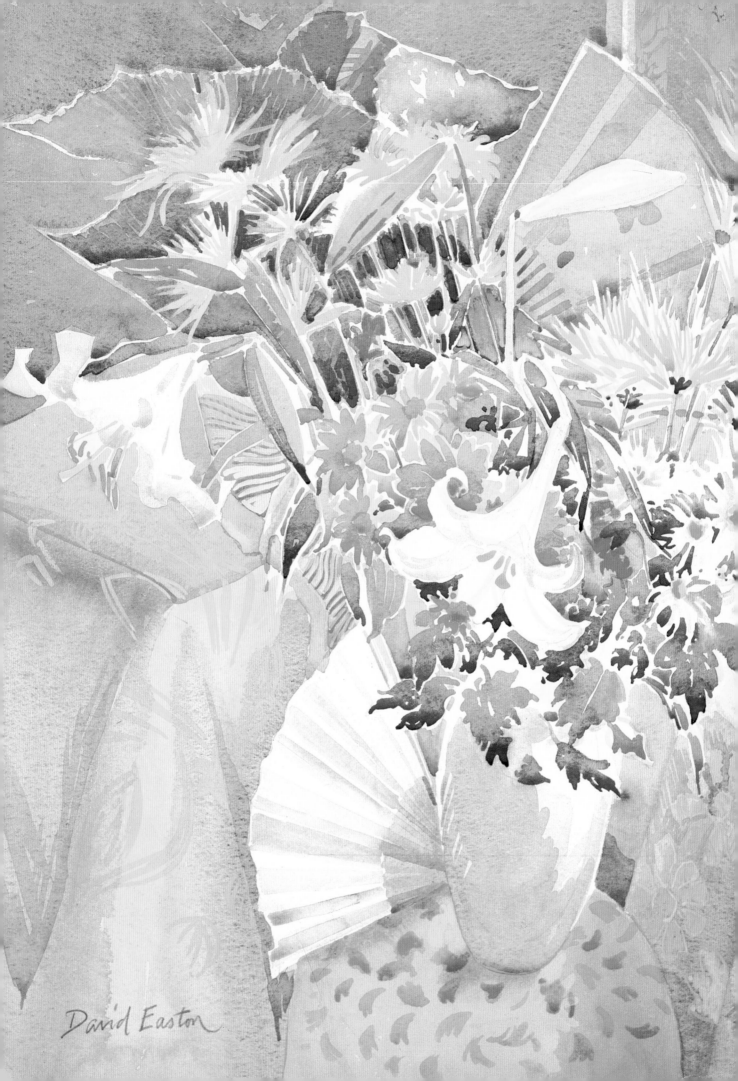

David Easton

WATERCOLOUR FLOWERS

David Easton

B.T. Batsford Ltd, London

First published 1993
Paperback edition published 1994

British Library Cataloguing-in-Publication
Data. A catalogue record for this book is
available from the British Library.

ISBN 0 7134 6487 9 (cased)
 0 7134 7604 4 (limp)

Typeset by Servis Filmsetting Limited,
Manchester
and printed in Hong Kong
for the publishers
B.T. Batsford Ltd
4 Fitzhardinge Street
London W1H 0AH

JACKET ILLUSTRATIONS

Front: **Nasturtiums and inula** *(detail). The full
painting can be seen on page 25*

Back: **Poppies and statue**. *Watercolour,
510 × 760 mm (20 × 30 in)*

Page 1: **Spring Flowers.** *Watercolour,
610 × 380 mm (24 × 15 in)*

Pages 2–3: **Autumn still life.** *Watercolour,
540 × 540 mm (21 × 21 in)*

CONTENTS

INTRODUCTION 7
A creative approach to flower painting 7

Chapter One WATERCOLOUR TECHNIQUES 8
Line and wash 10
Brush-drawing 14
Texture 20
Wet-in-wet 25
Manipulating fluid colour 29

Chapter Two ASPECTS OF WATERCOLOUR 32
Warm and cold contrasts 32
Opaque colours 34
Free styles of painting 37
Painting foliage 40

Chapter Three DRAWING AND COMPOSITION 44
Movement 47
Keeping a sketchbook 51
Composition 52

Chapter Four THEMES AND VARIATIONS (1) 59
Autumn 60
Poppies 67
Hydrangeas 79
Cyclamen 83

Chapter Five THEMES AND VARIATIONS (2) 89
Still-life contexts 89
Tulips 92
Irises 100
White flowers 108
Objective colour studies 110

Chapter Six PAINTING AND PRESENTATION 114
Working situations 114
The painter's vision 114
Framing and exhibiting your work 116

Chapter Seven COLOUR AND MATERIALS 118
The colour wheel and palette 118
Colour schemes 118
Using complementary colours 120
Colour mixing 122
Paints 122
Papers 124
Brushes 125

INDEX 126

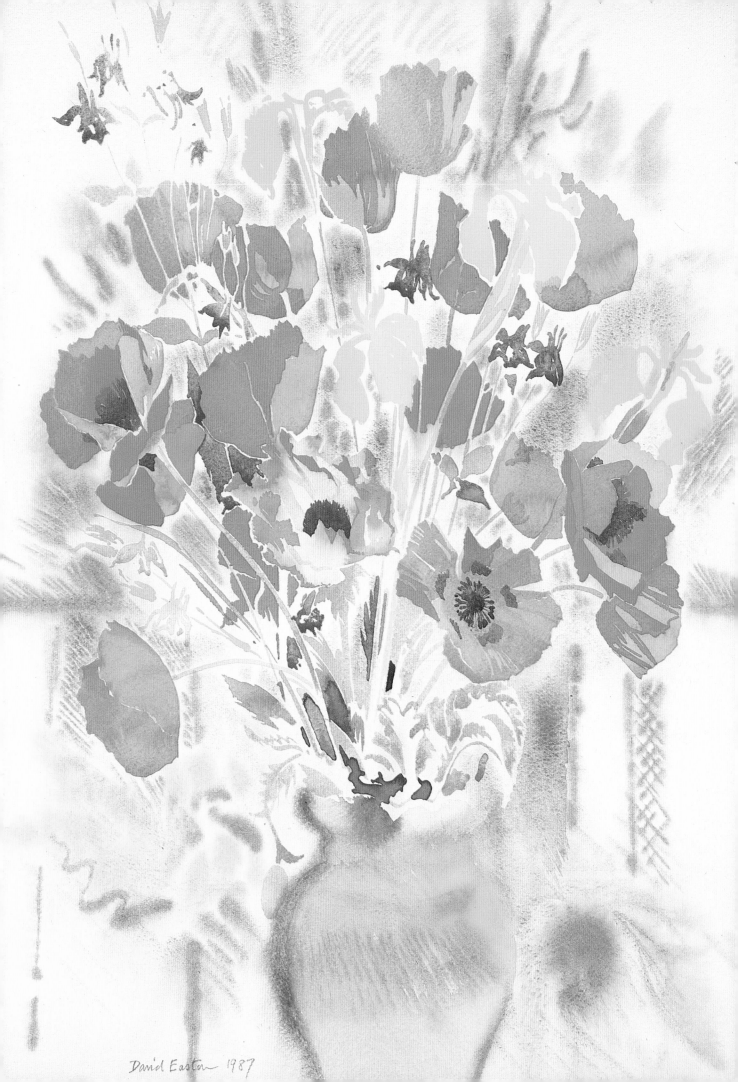

David Easton 1987

INTRODUCTION

A CREATIVE APPROACH TO FLOWER PAINTING

Watercolour is the ideal medium for flower painting. Transparency and colour could be described as the essence of both medium and subject: the white paper shines through the coloured brushmarks as light filters through petals. This book is designed to inspire readers to extend their range of expression when painting floral subjects in water-based colours. I do not advocate a particular style or method, but seek to encourage a number of different approaches.

Beginning with some techniques and aspects of picture-making, I then highlight drawing and composition. The following chapters develop themes based on just a few of the many flower families that have provided much of my inspiration in recent years. It seemed logical to set them out in this way, and to show something of the thinking behind each series of paintings. I conclude with hints about working situations, some pages on colour theory, mixing and schemes, and a resumé of basic painting materials.

Flowers are seen as a starting point for many visual journeys. They are chosen for their colours and shapes, in outdoor settings or in a still-life context. They form a very accessible and arrangeable source of colours which, whether saturated or more subtly hued, are not commonly found elsewhere. My approach is not that of the botanical artist. That discipline has its own conventions, demanding a high degree of control and accuracy in describing form and colour, and not usually allowing the brushwork to reveal individuality. Having said this, I do consider well-observed studies to be a vital element in my own work, and see little virtue in distorting the scale and habit of my subjects. At the same time, I stress the importance of allowing one's personal 'handwriting' to shine through.

Paintings should not disguise the fact that they are made of paint. Creativity springs from disciplined looking, followed by selective use of the observations. These are then marshalled by the painter, and presented with an emphasis of his or her choosing. Choices must include taking an attitude to the work, in terms of colour relationships and the placing of the subject within the rectangle. The most compelling flower paintings in the history of art reveal no fail-safe formulae – just many individual, inspired works.

I hope you will find increasing pleasure in your own work as you explore the medium and the subject, and find the occasional satisfying marriage which can exist between the two. It makes all the journeying worthwhile.

Poppies and flags. *Watercolour, 610 × 410 mm (24 × 16 in)*

WATERCOLOUR TECHNIQUES

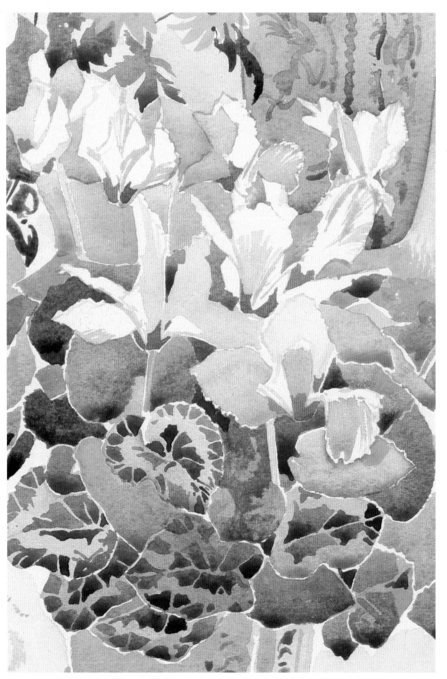

The traditional approach with water-colour is to build up the colours from light to dark, allowing each application of transparent colour to dry before overlaying the next. Flowers are often seen as light shapes on a dark ground, suggesting that the flowers should perhaps be painted first, and the setting added later. I find this to be a frequent procedure, but by no means the only option.

The following pages contain a range of uses of the medium, many of which address this situation. You will find some of these examples more relevant than others, because your own perception is unique. My intention is that you should be inspired to explore on your own account, adapting these ideas to suit your needs. Technique should never be regarded as an end in itself, but, by becoming conversant with the medium and the variables of paper, pigments, water and brushes, you will gain greater confidence.

Above all, you will be equipped to respond to the subject creatively, seeing it in terms of the modes of expression at your disposal. When I refer to seeing *in terms of* painting, I mean the habit of those who see the world with the eye of an artist. Artists develop the practice of mentally reconstructing the world in

Plant and flowers *(detail). 205 × 155 mm (8 × 6 in). The full painting is shown on page 62*

Lilies, *lifted out of an overall wash.*
165 × 165 mm (6½ × 6½ in)

Iris, *masked out before painting.*
Monochrome, 205 × 155 mm (8 × 6 in)

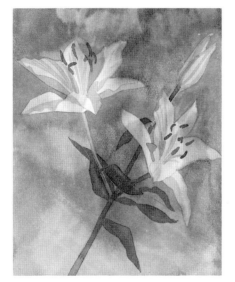

Lilies, *masked out over initial work.*
Monochrome, 260 × 205 mm (10 × 8 in)

paint, seeing attributes in the subject in the light of their picture-making methods. When looking, for example, at light flowers on a darker ground, there are several broad strategies you could adopt when starting a painting:

(a) the flowers could be painted first, and the background fitted round them

(b) the flower shapes could be lifted out of an overall wash

(c) the flowers could be reserved with masking fluid, and the background freely washed over

(d) the flowers could be painted on top of washes, or on a coloured paper, using opaque pigments

Any of these basic techniques, with variations or in combination, could be your choice. In each case, the salient features of the subject are perceived as *shape* and *relative tone values*.

In contrast, when you are working with a pen, pencil or in a linear way with the brush, you will be principally searching for *line elements* in the subject. Other ways of seeing come into play when the assessment of *colour relationships* is the main consideration. It is important to make studies in a range of media, and to tackle a variety of flower subjects and settings. These experiences should equip the observant artist to produce work of greater richness and insight.

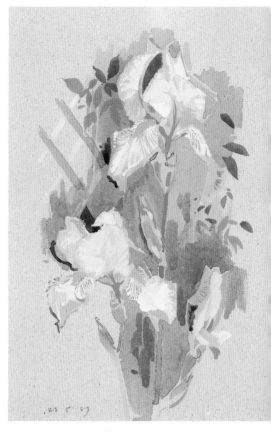

Yellow iris. *Watercolour and gouache on pastel paper, 410 × 255 mm (16 × 10 in)*

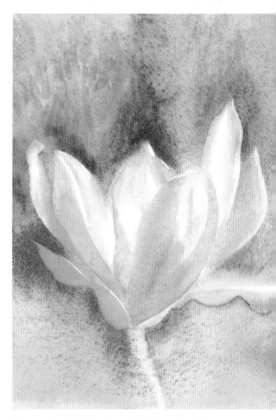

Magnolia. *Lifted out and heightened with white gouache, 280 × 215 mm (11 × 8½ in)*

9

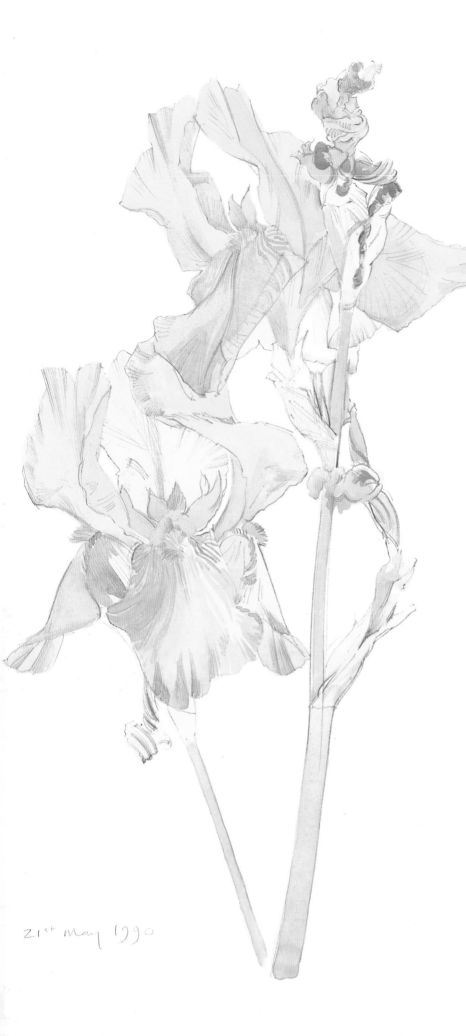

21st May 1990

LINE AND WASH

The technique of using pencil with watercolour is suitable for recording detailed information, or for stressing the linear movements of your flower subject. The line usually comes before the wash, but the order can be reversed. A fluid drawing could, for example, be given selective emphasis by means of an incisive pencil line.

In the sketches shown here, pencil drawings are serving different functions. On this page is a careful study made as reference for subsequent compositions. The watercolour provides the colour and tone information. The compositional studies opposite show the brushmarks made in counterpoint to the pencil. To erase the pencil would cause the sketches to lose their structure.

Paul Cézanne devised a fascinating method allied to this. He would begin with light pencil marks and cover them with a web of brushstrokes, allowing each layer of paint to dry before overlaying the next pure colour. The white of the paper continued to play a crucial role in these works, to such an extent that some people would consider them unfinished. Cézanne regarded them as complete statements. Make a point of seeking out Cézanne's watercolours, in good reproductions or in the flesh if you can. They have made a profound impression on many artists of this century.

Coloured crayons make for interesting variations on line-and-wash techniques, and the water-soluble types become a more integrated part of the work. Line and wash is a very useful technique to employ when you are working on location or gathering information quickly, as very little kit is required.

There is a difference between a pen drawing which has been 'coloured in',

Yellow iris. *Pencil and watercolour, 460 × 355 mm (18 × 14 in)*

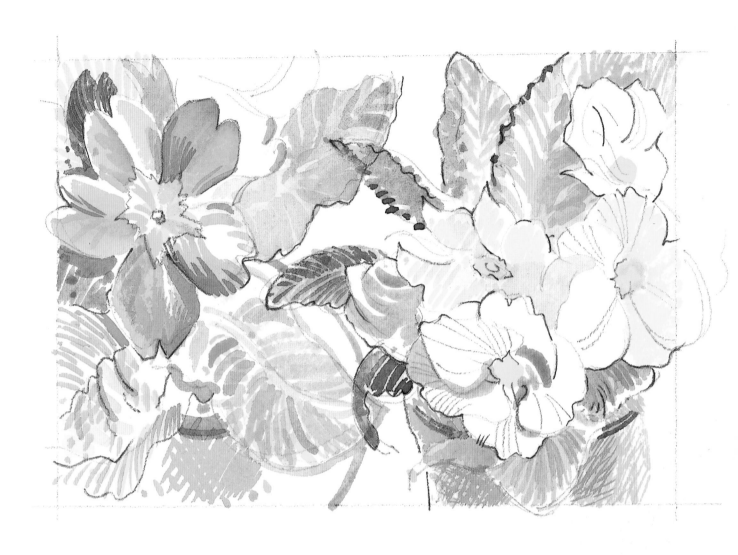

Study. *Pencil and watercolour,*
125 × 180 mm (5 × 7 in)

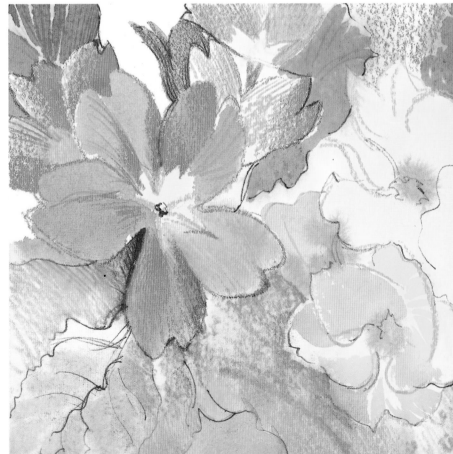

Study. *Watercolour, pencil and wash,*
155 × 155 mm (6 × 6 in)

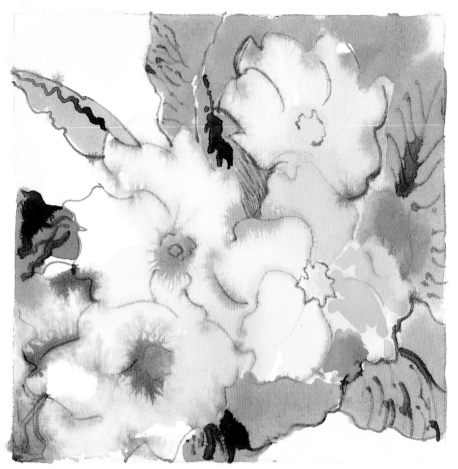

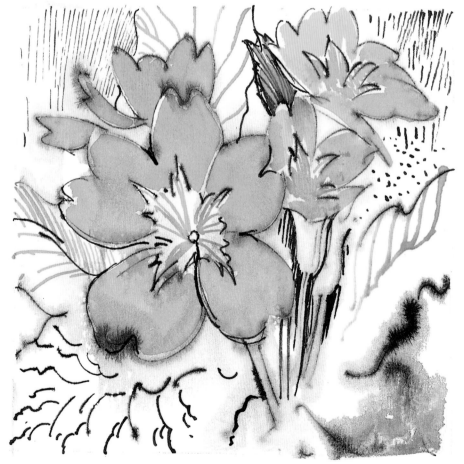

(This page and right) Three pen-and-wash variations

and a pen-and-wash drawing. Each medium can contribute in a positive way. The pen is an ideal implement for describing linear and well-defined detail; the brush supplies colour and tone. It does not matter which comes first.

The ArtPen, with unfixed ink, enables you to produce tonal washes simply by introducing clean water to the drawing. This gives a pleasing and natural association between the line and the washes. Waterproof Indian ink keeps its separate identity when colour is washed over the lines, but it becomes exciting and unpredictable when the ink is used to draw on top of a damp wash. The ink registers a line, but also spreads in a variety of ways according to the pace and pressure of the drawing action and the dampness of the paper.

I like to use a coloured ink as an occasional change from black. Another alternative would be to water down an unfixed black ink, to provide yourself with a range of grey tones. Dipping pens give a quality of line that is flexible and distinctly different from a fountain pen. Technical drawing pens are more limited, as they are not designed to encourage variation in line width. The illustrations on these two pages are a small sample of the many permutations you could explore. Try to keep in mind a balance between technique and observation: the former should serve the latter.

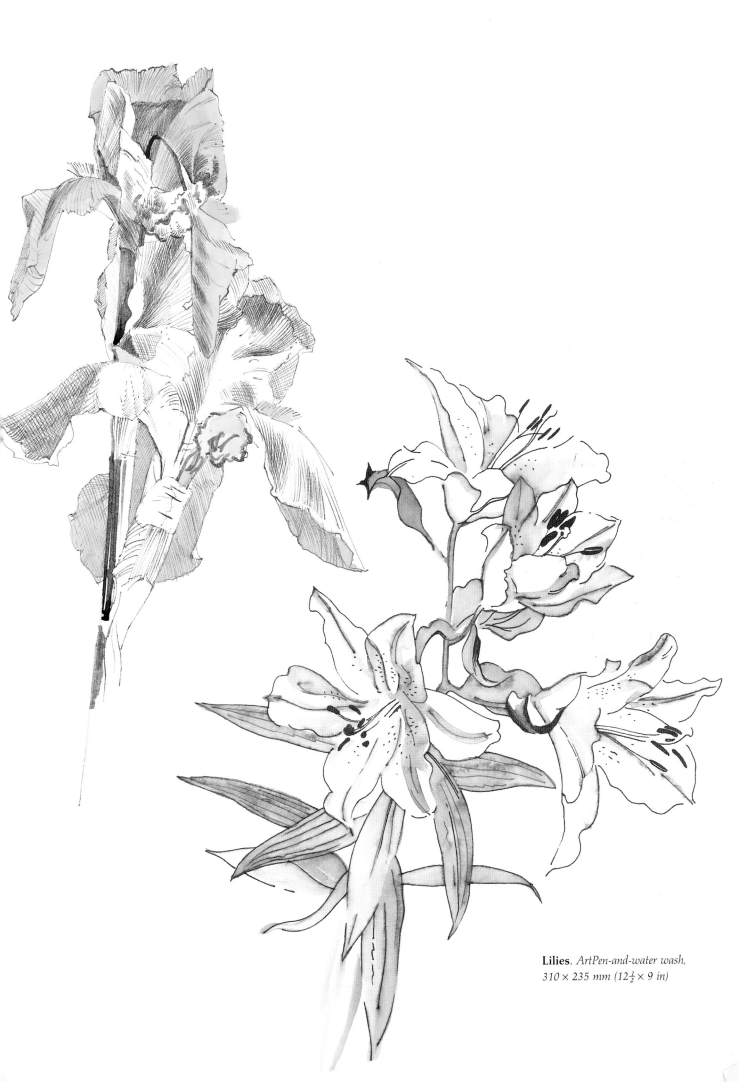

Lilies. *ArtPen-and-water wash,*
310 × 235 mm (12½ × 9 in)

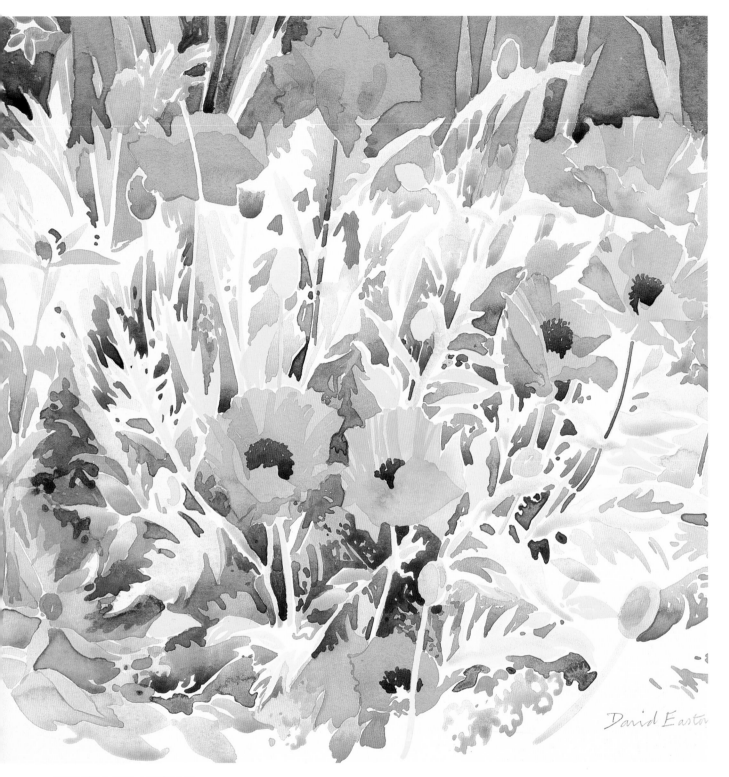

BRUSH-DRAWING

Differences between brush-drawing and painting are neither clear nor of great consequence. I suppose the word 'drawing' suggests line, but the brush can make many marks which do not fall into convenient categories. The last thing you want on your mind, when your brush is poised over the paper, is an analysis of the act of mark-making.

A positive goal for the artist is to develop the means by which to express something about the subject being painted. Brushwork is like handwriting: uniquely personal.

Poppy garden. *Watercolour on tinted paper, 330 × 330 mm (13 × 13 in)*

Starting a work is always difficult. The paper is blank, and the first few marks look crude and vulnerable. Patience is hard to learn, but, as the marks proliferate and you become engrossed, the work starts to take

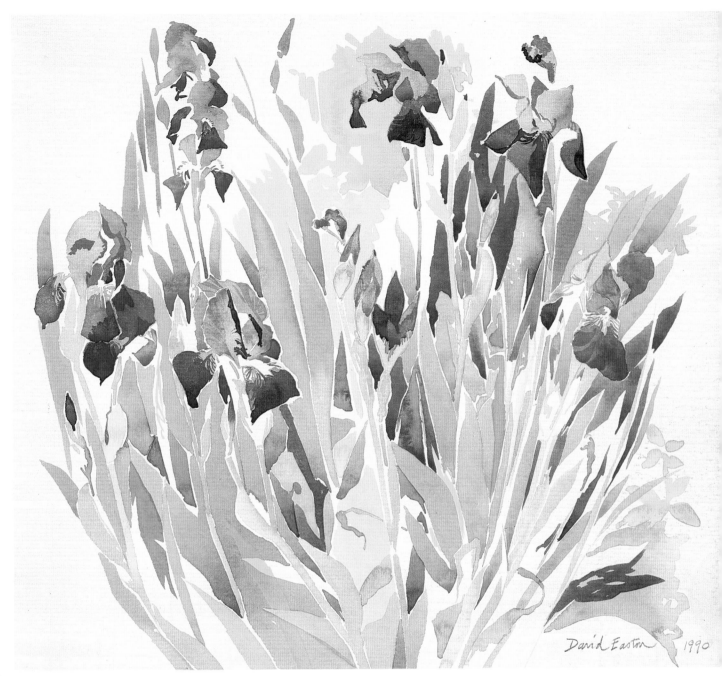

Purple irises. *Watercolour on pastel paper, 435 × 485 mm (17 × 19 in)*

shape and the image relates to the page. Don't expect instant results. Be exacting in your observation, concentrating on the subject, and accept the imperfections of the marks you make.

Resist the impulse to put the brush back into drying paint. Spontaneous shapes, having the character of the subject, will be much more satisfactory than the accurate but lifeless shapes achieved by laboriously pushing the paint around until it loses freshness. The aim should be to lay

your strokes deliberately and leave them to dry naturally. There is nothing finite about the shape of a petal. You can never say that any mark is right, in the sense of literally accurate. Flowers are living things, they are on the move, they are seen in perspective, in changing light and with the viewpoint altering at every slight movement of your head. Concerns about reproducing exactly what you see are counter-productive. The subject is the *starting point* for your creative interpretation.

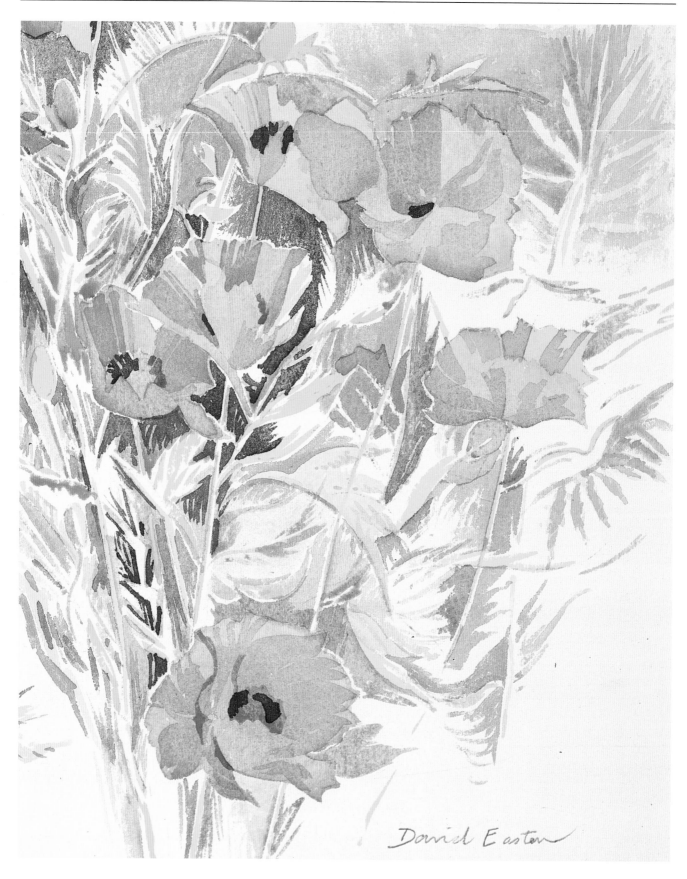

Poppies *(detail). 255 × 205 mm (10 × 8 in). The full painting is shown on page 67*

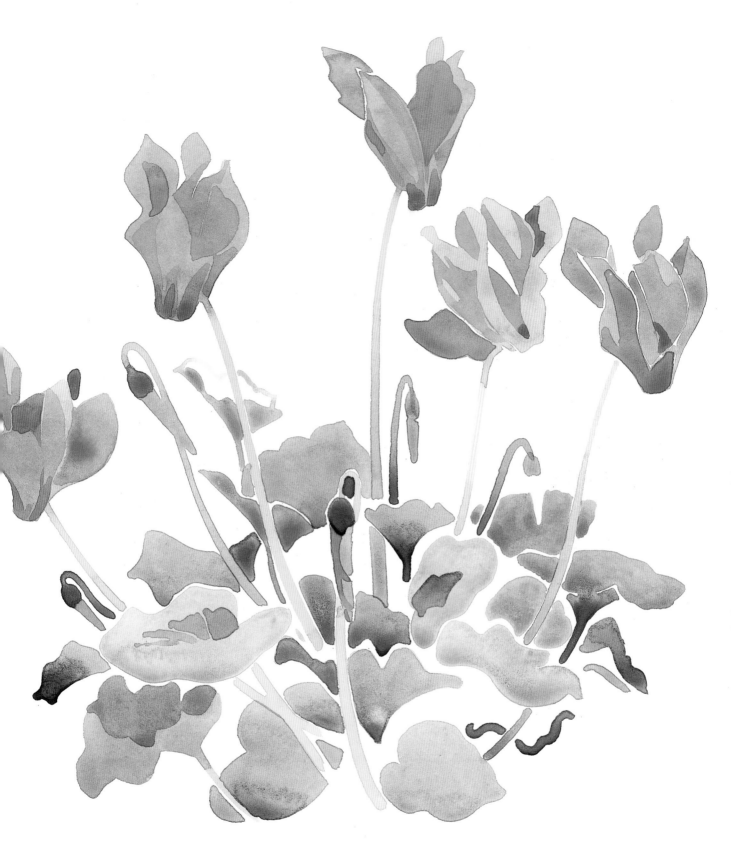

The paintings on pages 14–17 are examples of work on four different supports. Two are on watercolour paper; the others on cartridge and coloured pastel paper. Each responds to the brush in its own way. The range of colour, tone, degree of colour saturation and transparency, directness of touch – all are considerations as the subject is translated in terms of marks and stains on paper.

Pink cyclamen. *Watercolour on cartridge paper, 220 × 220 mm (8½ × 8½ in)*

17

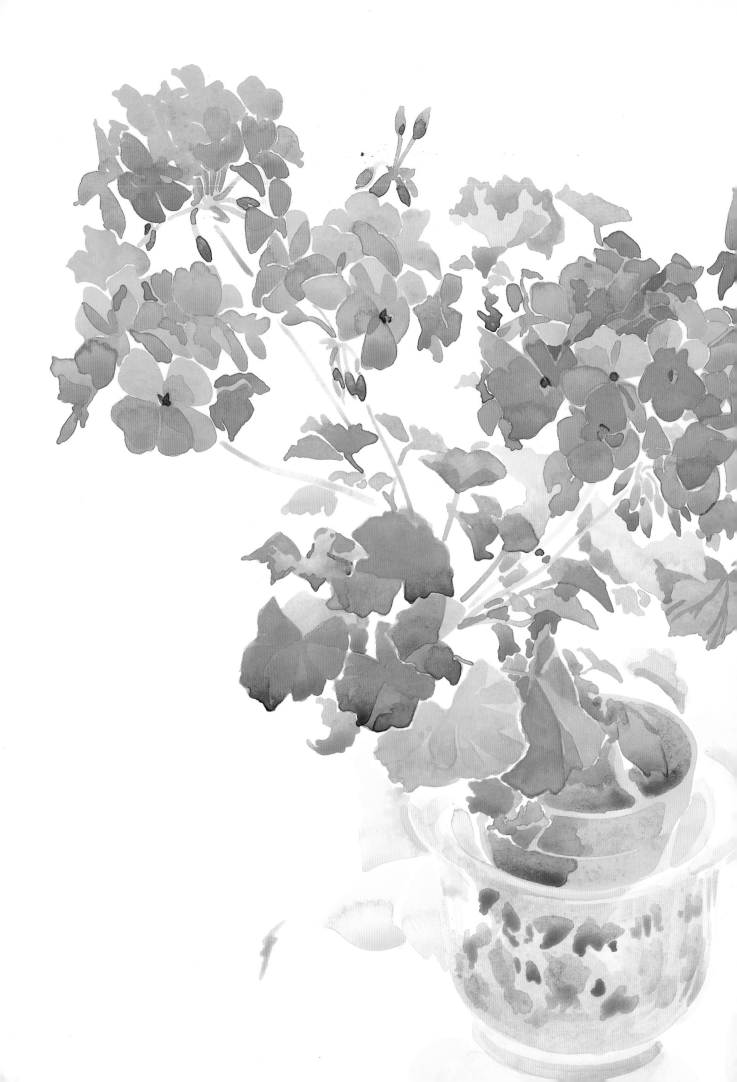

Pelargonium. *Watercolour on hot-pressed paper, 380 × 435 mm (15 × 17 in)*

This pelargonium sketch shows dozens of petals, some fused together in clumps, others seen individually. No two petals are identical in shape, size and colour, yet collectively they are unmistakable. The same is true of the leaves. This sketch was painted on a hot-pressed paper, which encourages the use of crisply defined edges. On this surface, the colour tends to collect at the edges of a shape, in a way that resembles the effect that is obtained when using good cartridge papers.

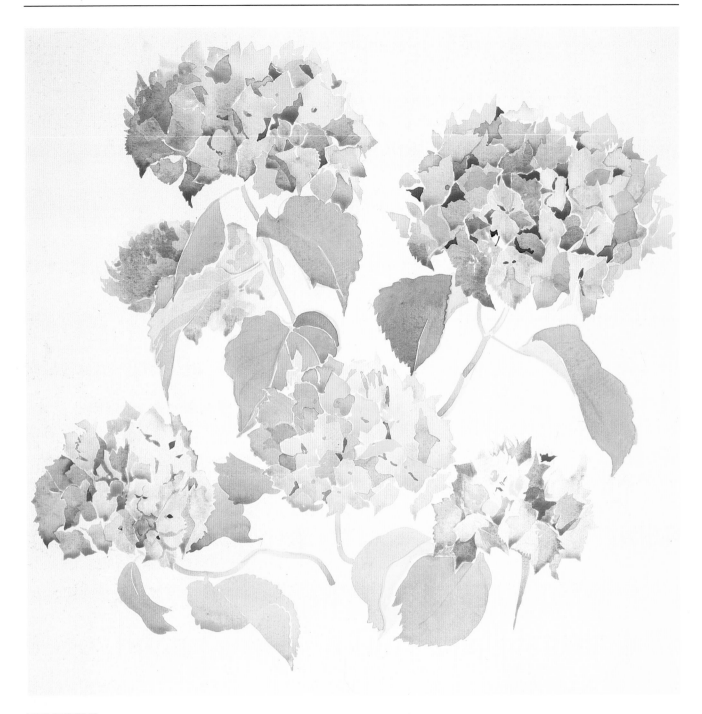

TEXTURE

One of the most effective means of creating texture is to assemble your brushmarks in ways which set up interactions. Even without colour contrasts, you can use spotted or hatched strokes, allowing the paper to flicker through to varying degrees. Opposing directions of marks set up oscillation in the eye. Colour contrasts are another element of textural richness, and you can, of course, exploit the capacity of certain pigments to give granular texture. Active textural areas in a painting can be given emphasis and interest by the presence of passages of quieter, smoother texture.

The choice of paper is vital. Smooth papers make more demands on the painter in the way of diversity of mark: you have to make your texture with some deliberation. Brushstrokes laid on a rougher surface tend to break up, and to highlight the

Hydrangea study. *Watercolour, 540 × 540 mm (21 × 21 in)*

texture of the paper itself. This is more evident when drier or thicker paint is applied. As well as achieving texture by adding marks, washing out can be another part of the process.

The hydrangea flowerheads above were painted directly with the brush,

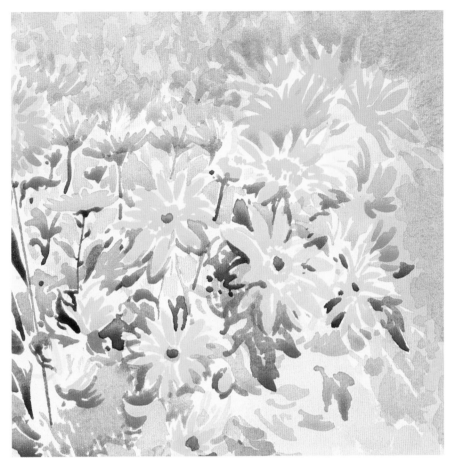

shape by shape. I used pointed sable brushes, sizes 4 and 6, and worked with the board at a slight slope to allow the marks to move down the hot-pressed surface. This is the usual practice when you need to have control over fluid marks, as it allows the pigments to deposit themselves evenly on the paper. Many painters prefer to work flat, and to let the paint dry in less predictable ways. Both methods are valid, although either can become too much of an unthinking habit.

Another painting of this plant, which I made at the same time, developed into a more complete composition and is shown on page 80.

One of the things to bear in mind when building individual shapes into a form is the control of tone values. I have worked from light, through mid- and on to dark tones, often modifying a tone with a subsequent wash of colour. These later marks will, of

Flowers/peppers/fans (detail).
c. 180 × 180 mm (7 × 7 in). The full painting is shown on page 60

course, make these areas darker, but may also give a warmer or colder colour cast. A well-defined side light also helps to reveal the volume.

You may prefer to include greater detail in your work. If this is the case, I would still advocate a method that deals with shapes first. It is always possible to elaborate on these by working over with linear textures: when adding leaf veins, for example. If you attempt to complete small corners of a painting before you have established the broad composition, you are likely to lose control of the overall tonality.

Texture and pattern are closely allied. Both are about variegated surfaces, but on different scales. Texture reveals itself when the work is seen at close quarters; pattern can be appreciated at longer range.

Brush textures: size 4 sable, Whistler Oxette, Chinese brush (see page 125 for more about these brushes)

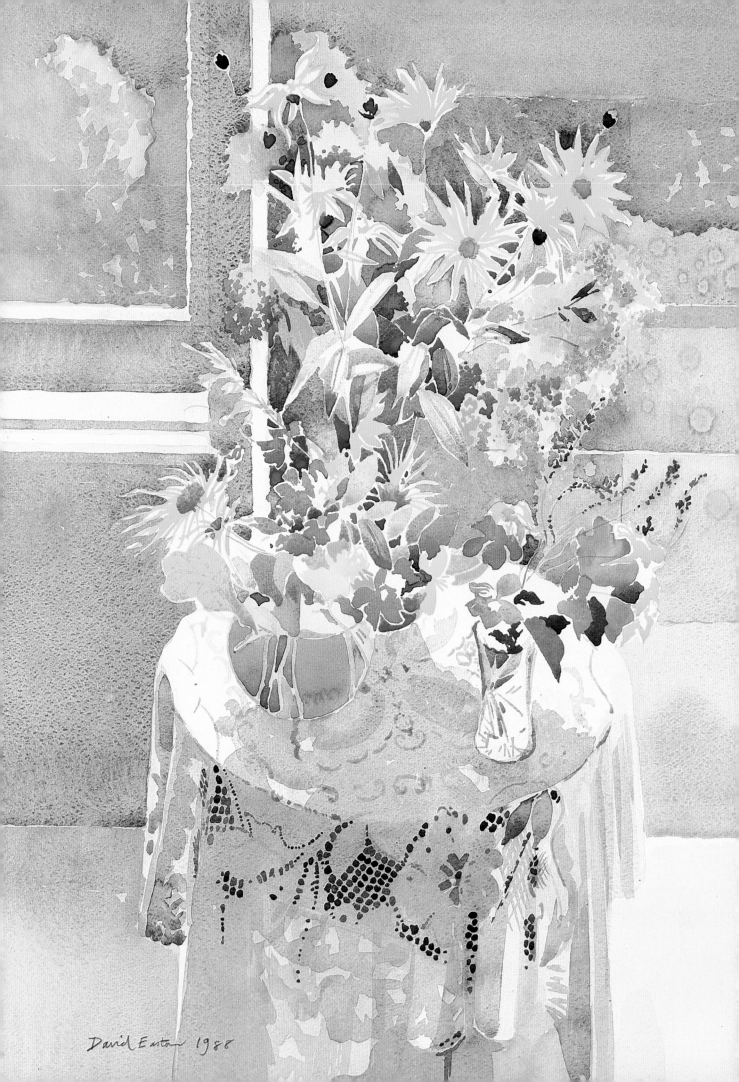
David Easton 1988

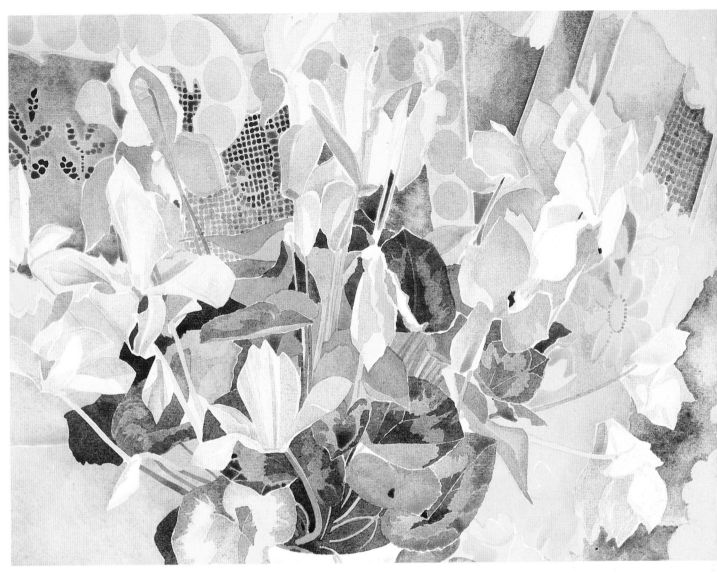

(Above) **White cyclamen** *(detail).*
355 × 460 mm (14 × 18 in). The full
painting is shown on page 85

Flowers in the window (opposite)
contains a host of small, very varied
shapes, some clear-cut and others soft.
The brushmarks go from dots to
broader washes. Sharp touches of
primary colour emerge from neutral
areas. Shapes of white paper are part
of the scheme, helping to give
structure·to the work.

White cyclamen (above) combines
similar treatment of the background
fabrics and the plant, drawing both on
to the picture plane in a flat design.
Patterns and textures are more
important because the colour is
restrained. The whole image is shown
on page 85.

Oriental still life (overleaf) contains
a great deal of linear brushwork that
is almost calligraphic, in response to
the many patterned items in the
subject. This is controlled by the
broader geometry of the design as
a whole.

(Left) **Flowers in the window**.
Watercolour, 540 × 355 mm (21 × 14 in)

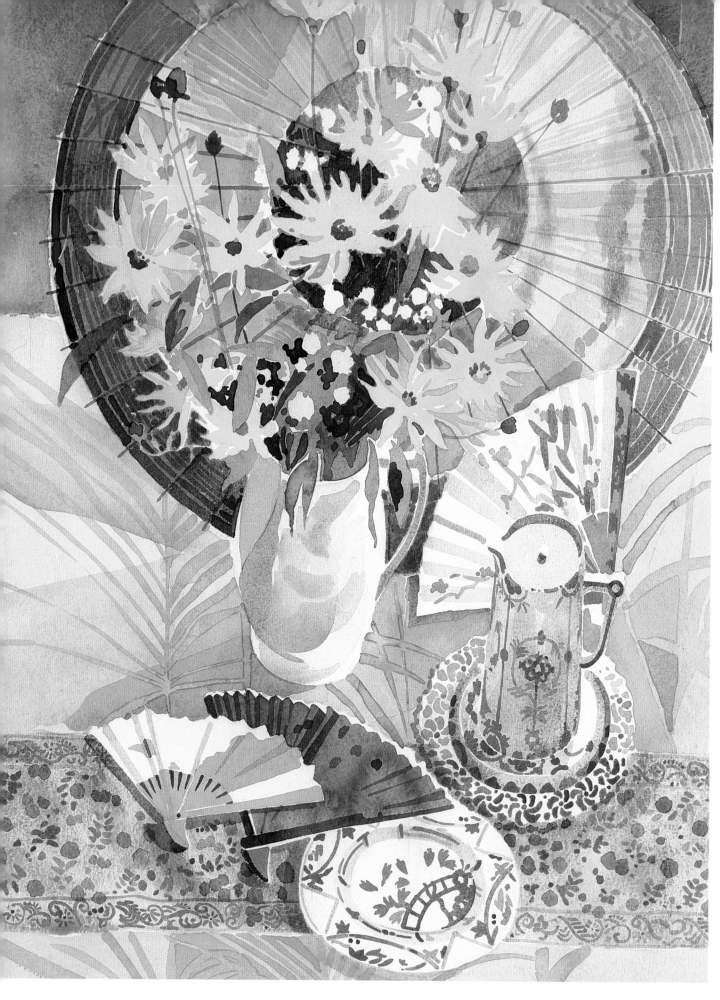

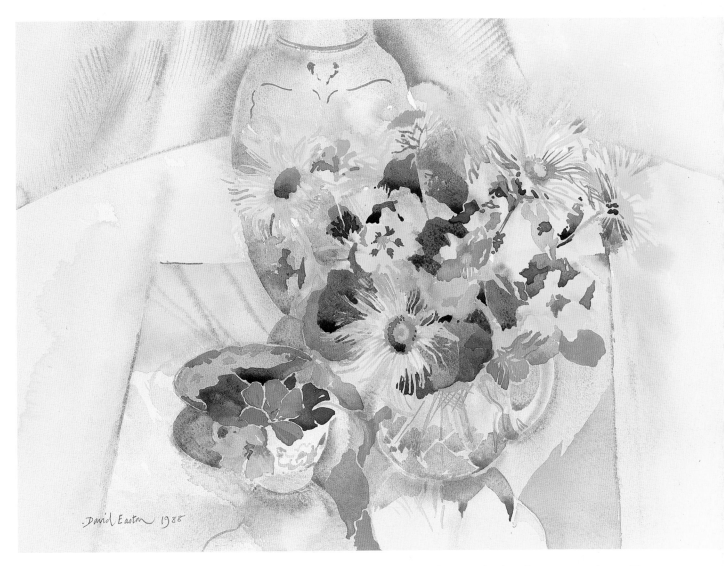

(Above) **Nasturtiums and inula**.
255 × 305 mm (10 × 12 in)

WET-IN-WET

Painting wet-in-wet can be exciting. It is an unpredictable technique, and demands alertness. You need to be able to recognize good things as they are happening, and to capitalize on the happy accident. It can become addictive, seeming to replace more solid virtues of construction and drawing. I have seldom seen totally wet-in-wet works that continue to satisfy after long acquaintance. I

prefer to see the technique as part of an image, and to enjoy the contrast of images part-diffused and part-focused.

Some of the most rewarding aspects of working on a fluid surface seem to be about colour. Unusual and instinctive associations occur, giving life and poetry to the work. I suppose that the best wet-in-wet paintings have a quality of being inimitable. Try your own version of a painting by Emile Nolde (see page 116). Your work will not be a facsimile, but you will learn from the experience, and perhaps gain some insight into the thinking of the artist.

A useful way to get into a painting is to start on a wet surface, and to see your marks gradually become more defined as the paper dries. I used this

method in the painting above. There is a certain sense of security in knowing that your initial marks will almost disappear, and that you can sketch in a ghost of an image before committing yourself to anything indelible.

(Left) **Oriental still life**. *510 × 355 mm (20 × 14 in)*

The sketch on the left began with a wash of pink. Reds and yellows claimed a space when they were dropped in, and blues and greens were added as the wash settled. The paper is a Fabriano rough.

Poppy flowerheads (opposite) includes wet-in-wet. It was partly washed out, with further work added when the paper had dried. *Mixed irises* (overleaf), painted on a cream pastel paper, also started with a wet surface. The paint behaves in slightly unpredictable ways on the laid paper, even when it is almost dry.

Tulips. *Watercolour, wet-in-wet, actual size*

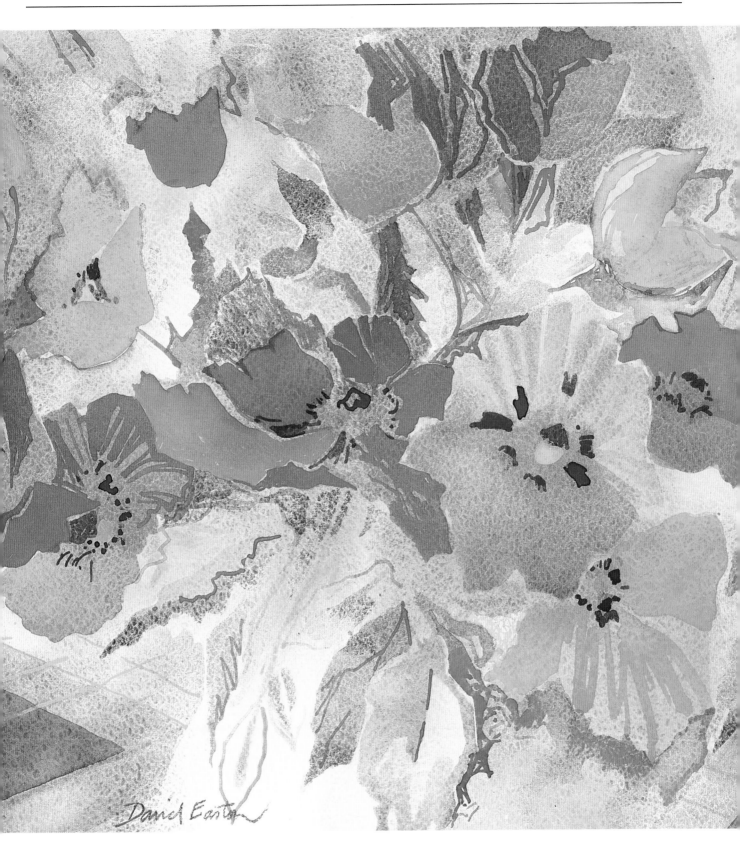

Poppy flowerheads. *Watercolour,*
305 × 305 mm (12 × 12 in)

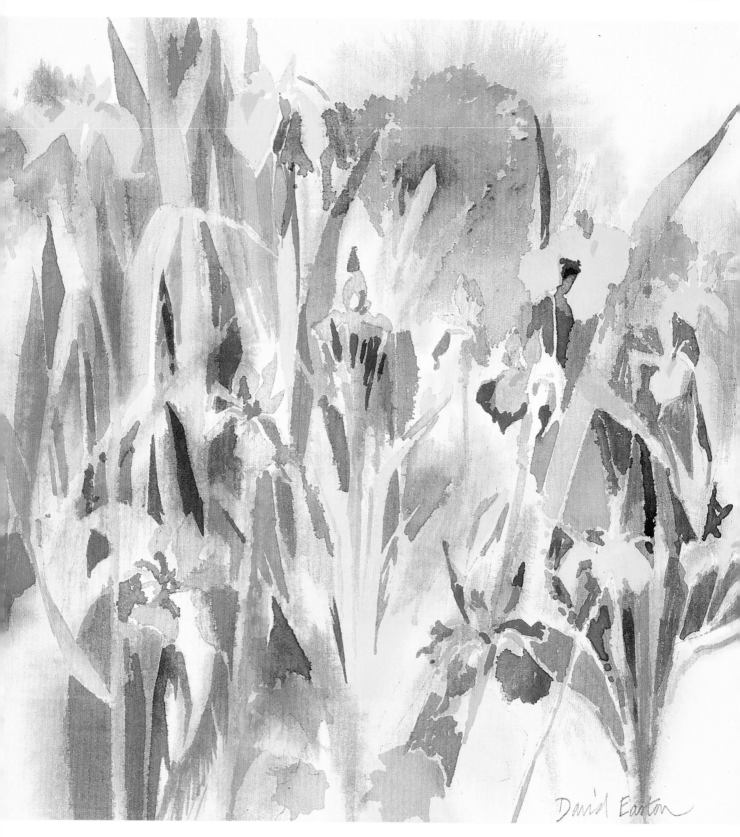

Mixed irises. *Watercolour on pastel paper,*
300 × 300 mm (11½ × 11½ in)

MANIPULATING FLUID COLOUR

Watercolour is a superb medium for translating delicate transitions of colour and tone. This involves painting wet-in-wet, but differs from the technique described on page 25 in that the paper is dry at the start. The wet shapes into which paint is applied are mostly contained by dry areas, and the technique is therefore much more controlled.

Another interesting set of effects can be obtained by dropping clear water into a rich wash of contained colour. The water tends to push the pigment to the outer edges of the shape, and this can give a special bloom to a petal, for example. The method used in the poppy painting on pages 72–3, of which a detail is shown here, is very straightforward. The petals were painted with a light orange/yellow mix, and a brushload of Cadmium Red was judiciously touched into the wet areas. These marks were allowed to dry, and the darker accents of flower markings and foliage were added last. Practice is needed both in making the shapes with your pointed brush and in judging the strengths of the various colours.

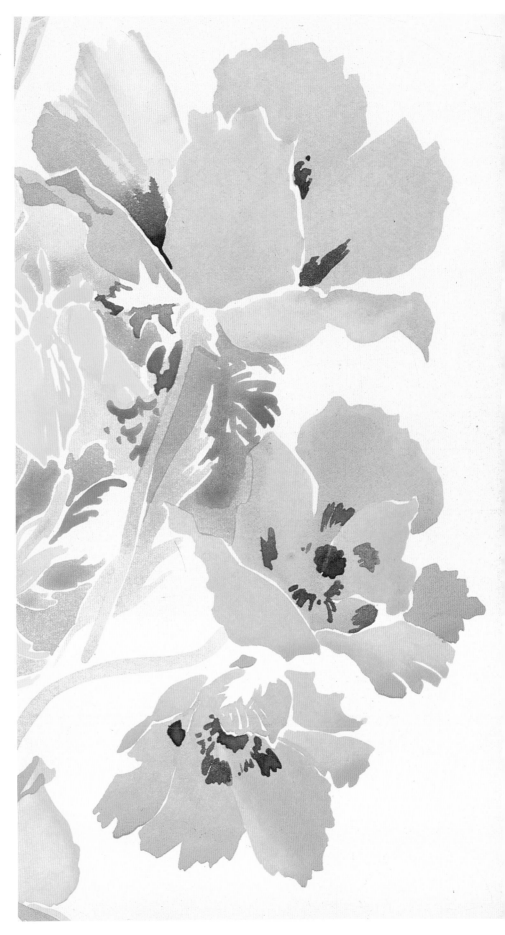

Poppies and yellow flags (detail). 280 × 165 mm (11 × 6¼ in). The full painting is shown on pages 72–3

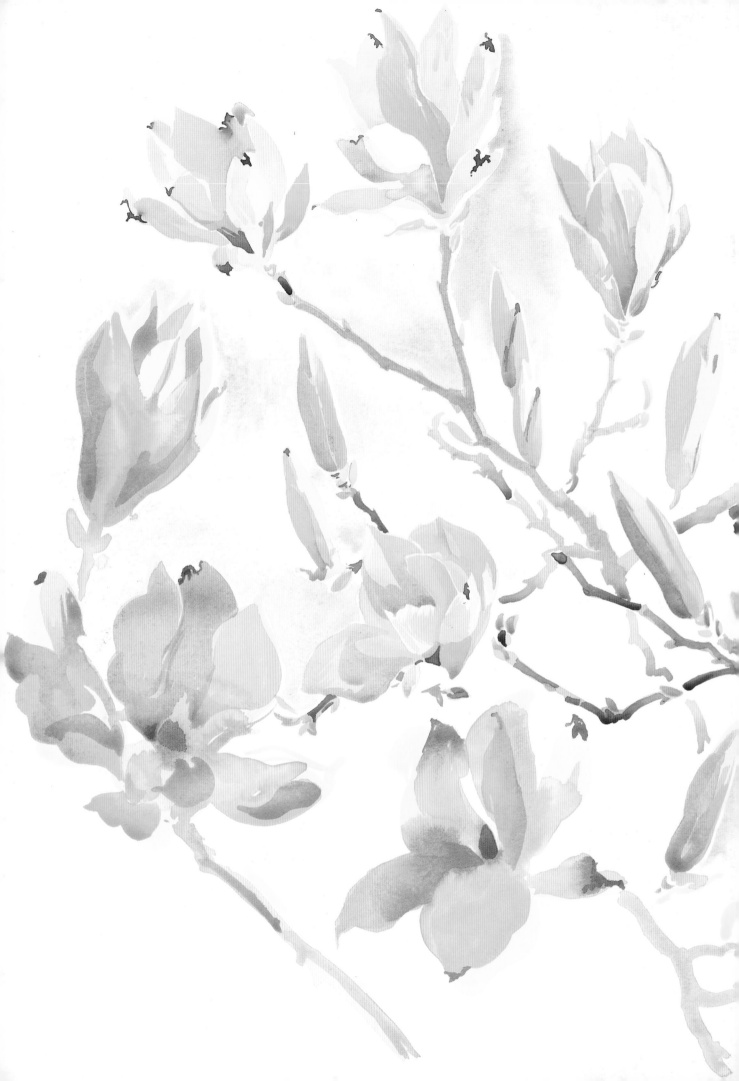

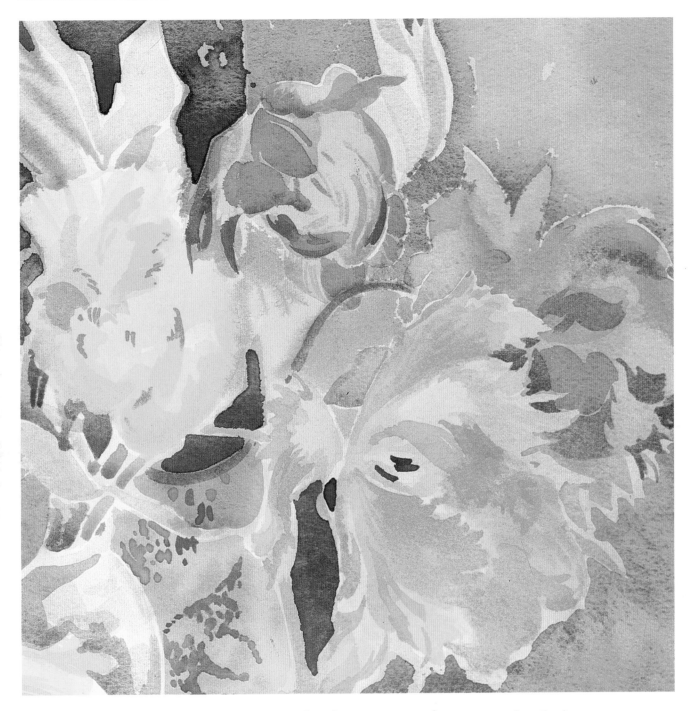

In other parts of this painting (see pages 72–3), the dark accents were added before the paint was completely dry, giving a softer effect. The magnolia sketch opposite was painted a little more freely, the shapes only emerging after several quick washes had been built up. Some were then washed out with clear water, having become too heavy.

Magnolias. *Watercolour, 355 × 280 mm (14 × 11 in)*

Parrot tulips (above) is an example of a combination of free washes within shapes, given emphasis by means of deeper surrounding washes which key the edges here and there. The opacity of Naples Yellow contrasts with, and partly resists, the wash of blue/violet, supplying a passage of colour interest in the background. The whole painting is reproduced on page 95.

Parrot tulips *(detail). 305 × 305 mm (12 × 12 in). The full painting is shown on page 95*

ASPECTS OF WATERCOLOUR

WARM AND COLD CONTRASTS

Colour temperature can best be assessed in relation to the colour wheel (see page 118). The warm half comprises *red, orange* and *yellow*; the cold half consists of *green, blue* and *violet*. There is more to it than this, however, because we can also speak of a 'warm blue' or a 'cool red'. Colours have these properties according to the context in which they are seen. At this point, I simply draw attention to the practical value of using these polarities, firstly with the aim of creating form.

My amaryllis painting, of which a detail is shown here (full painting on page 57), takes much of its form from the warm yellow light set against the mainly blue shadow areas. This was how the subject actually appeared, but the colours were given a purer hue and a higher key. Tone values can be kept in a closer range when the colour contrast is present. White, which contains all colour, enhances the lightness.

August flowers (opposite) illustrates another use of the combination. It shows one of many warm/cold pairs of pigments that I have employed as a limited palette when starting a painting. The point here is about unity of colour composition, rather than form. Alternate washes of Raw Sienna and French Ultramarine were used to set up the framework in a

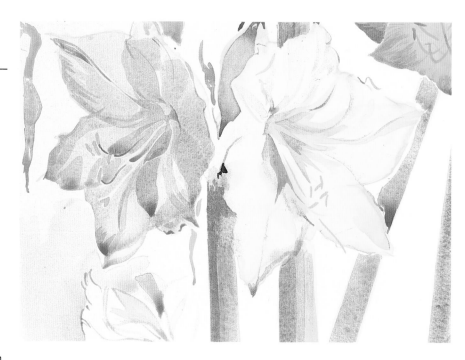

tonal underpainting. The local colour of the flowers came in towards the end. Viridian Green was used in some of the foliage to contrast with the grey-greens which resulted from overlaying the first colours. The sketch was followed quite closely, and served to define a grouping of rounded shapes, held in place by verticals.

Amaryllis (detail). 230 × 305 mm (9 × 12 in). The full painting is shown on page 57

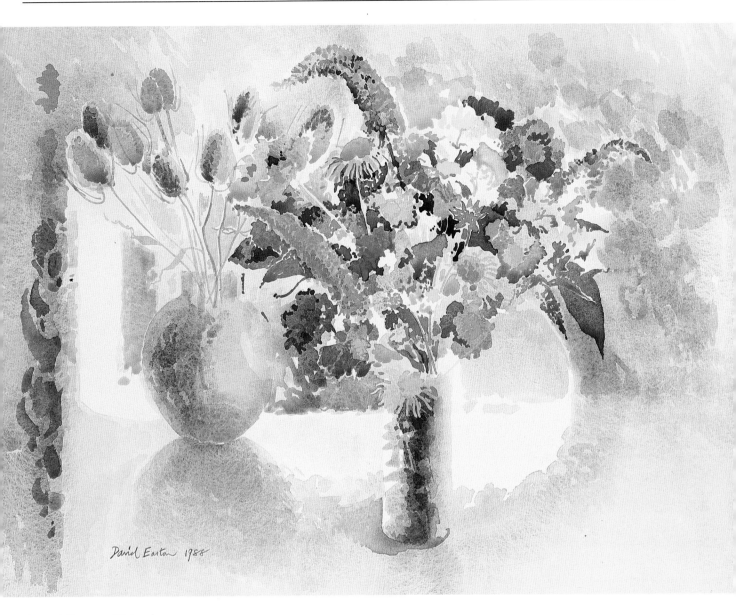

August flowers. *Watercolour,*
410 × 510 mm (16 × 20 in)

Study for **August flowers**. *Pencil and*
watercolour, 155 × 190 mm (6 × 7½ in)

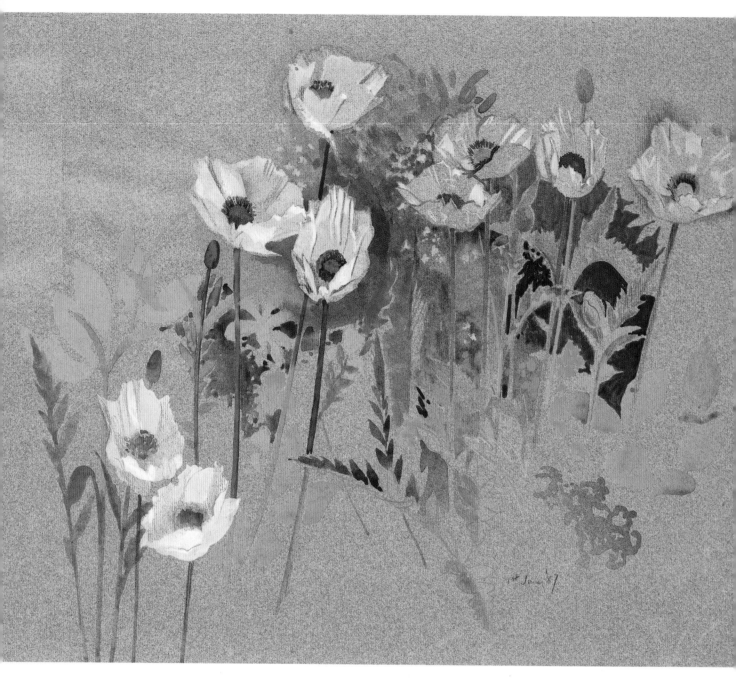

White poppies. *Watercolour, crayon and gouache, 410 × 510 mm (16 × 20 in)*

OPAQUE COLOURS

Opacity might be the last attribute that you would associate with water-colours, but in the general context of water-based painting it plays a useful role. From a practical viewpoint, it must be a good idea to tackle the subject in the most straightforward way from time to time.

When making studies, for example, you are simply concerned with gathering information. The way the studies are later used, in terms of technique, is a different matter. It may be satisfying, to the purist, to reserve even the tiniest and most complex shapes of light in the picture, building the work around them. I often prefer to use a white pigment to heighten a work, having first chosen the colour and tone value of the paper. A cool neutral has been the choice for the painting above, but stronger and

more positive colours can be used as a foil to the predominant colours of the subject.

The examples on these two pages and overleaf are all of white-flower subjects, but other opaque media were used in the colour studies on pages 110–13. My other white-flower paintings, shown on pages 108–9, were produced without resorting to white pigments.

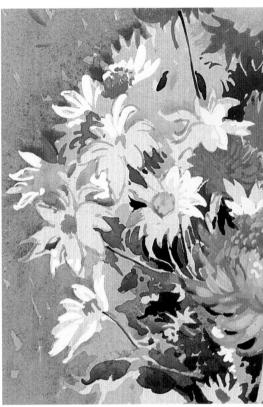

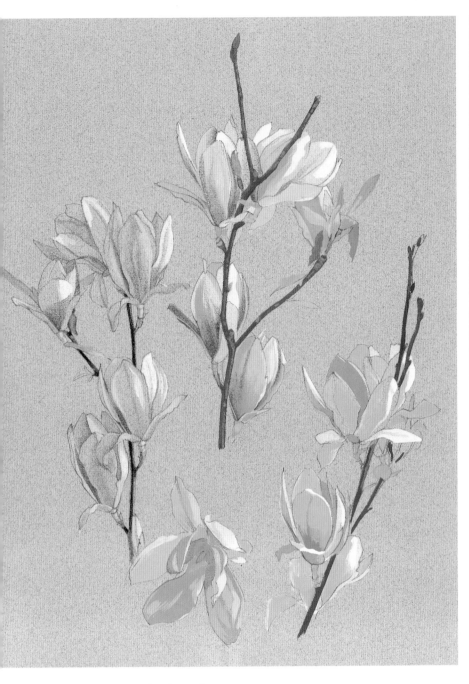

Magnolia studies. *Pencil and gouache,*
435 × 342 mm (17 × 13½ in)

Chrysanthemums *(detail). Watercolour*
and gouache, c.165 × 128 mm (6½ × 5 in).
The full painting is shown on page 63

The detail from *Chrysanthemums*
(above) shows a combination of linear
brushwork with opaque white used to
heighten the light accents. The tone
of the paper is very much part of the
scheme, partly modified with
transparent washes. The complete
painting is shown on page 63, where
you can see that other passages of
opaque painting are used to pick out
pattern features.

Opacity is not only about whites.
Many of the yellow and warmer-red
pigments have a density of substance
that can cover effectively, or can repel
subsequent washes, causing them to
separate in interesting ways, as we
saw in the examples of textural
painting on pages 20–3.

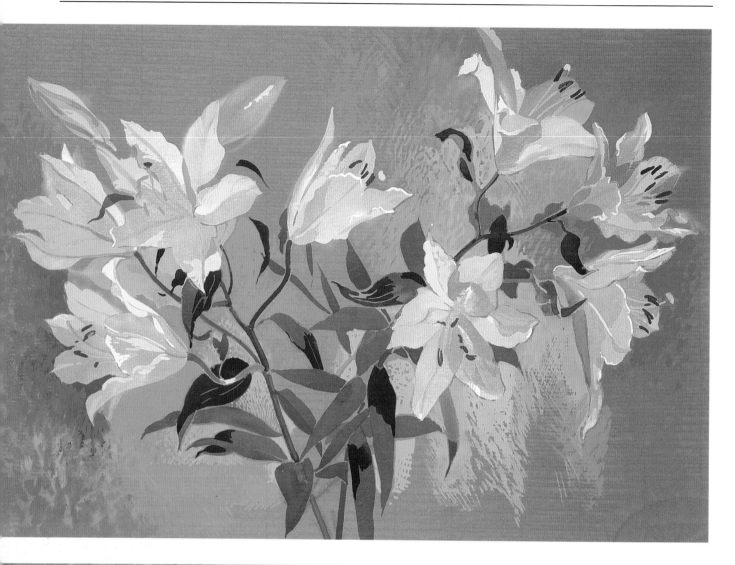

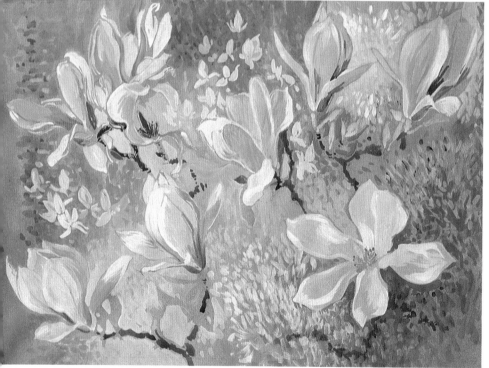

(Above) **Lilies**. *Gouache on Fabriano Roma pastel paper, 330 × 460 mm (13 × 18 in)*

Lilies (above) was painted on a much darker paper, and is opaque throughout. The broad distribution of flower and leaf shapes was established first. The flowers were then built up in stages, with the extreme light and dark marks coming last. Some adjustment of the background paper colour and tone was also introduced. This was in response to the ways in which the flowers registered against the setting, and with regard to the composition.

The freer painting of *Magnolias* (left) was a less calculated work. The paint was stippled and splashed on

Magnolias. *Gouache on pastel paper, 355 × 460 mm (14 × 18 in)*

rapidly. Small brushmarks break across the paper, in contrast to the broader, sinuous strokes of the flowers. There is often a spirit about the rapid sketch which is difficult to recapture in more carefully structured works.

FREE STYLES OF PAINTING

The painting on this page, and those shown overleaf, may not be markedly different from others in the book, but they have a freer approach in common. Each was painted after a period of concentrated work on exacting subjects.

October harvest (right) was prompted by the acquisition of a richly patterned scarf and the green-glazed pot. It was a response to the exciting colour, especially the complementary red/green pairings. Alternative versions of this subject are included in the compositions on pages 54–5.

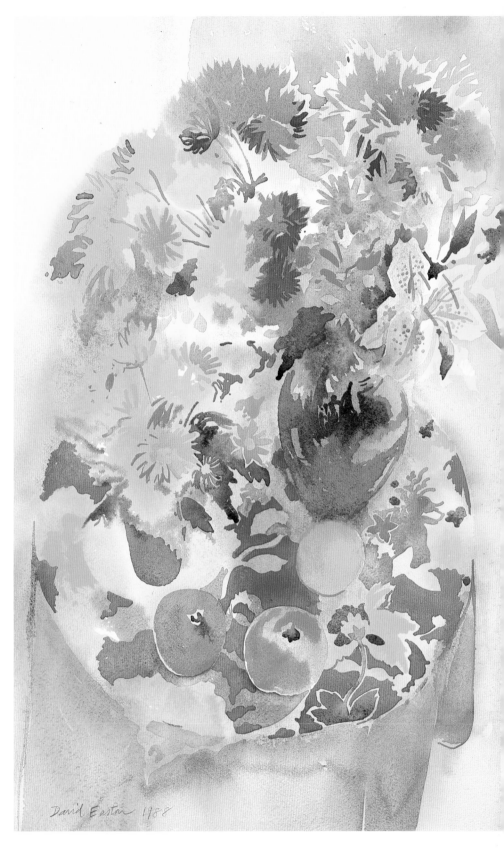

October harvest. *Watercolour, 635 × 410 mm (25 × 16 in)*

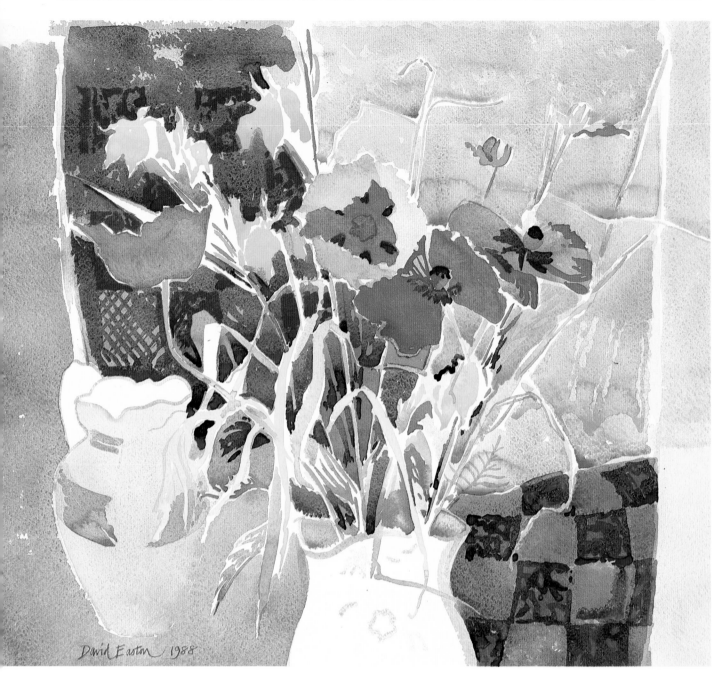

Flower composition. *Watercolour, 540 × 560 mm (21 × 22 in)*

In *Flower composition* (above) I sought to balance the dark diagonal areas, echoing this pattern by means of the chequered fabric, and to carry the yellows and straw colours through the composition, making connections with the other diagonal. The painting is intended to have tension rather than repose.

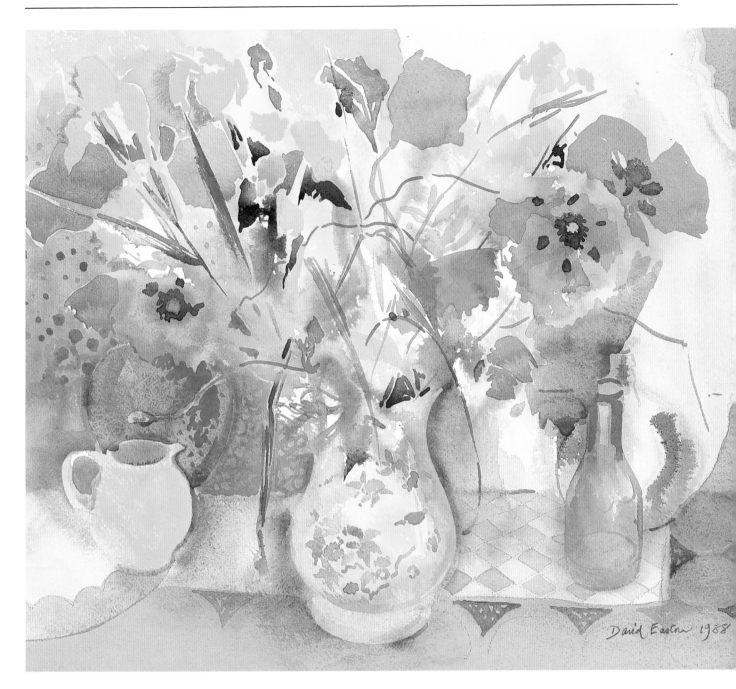

Still life with flowers. *Watercolour, 460 × 560 mm (18 × 22 in)*

The energy of primary colours enlivens *Still life with flowers* (above), and much of the work owes more to instinct than intellect. I found the interplay of crisp and soft areas absorbing. Some of the yellows were laid on with maximum intensity, and I think the blue passage works because it is in a close-toned area. Whatever the outcome, I find it pleasurable to let go of the usual restraints, and to enjoy the exhilaration of handling pure colours from time to time. Drawing is not thrown overboard in the process, but it is not necessary to prove a point about your technical control every time you paint.

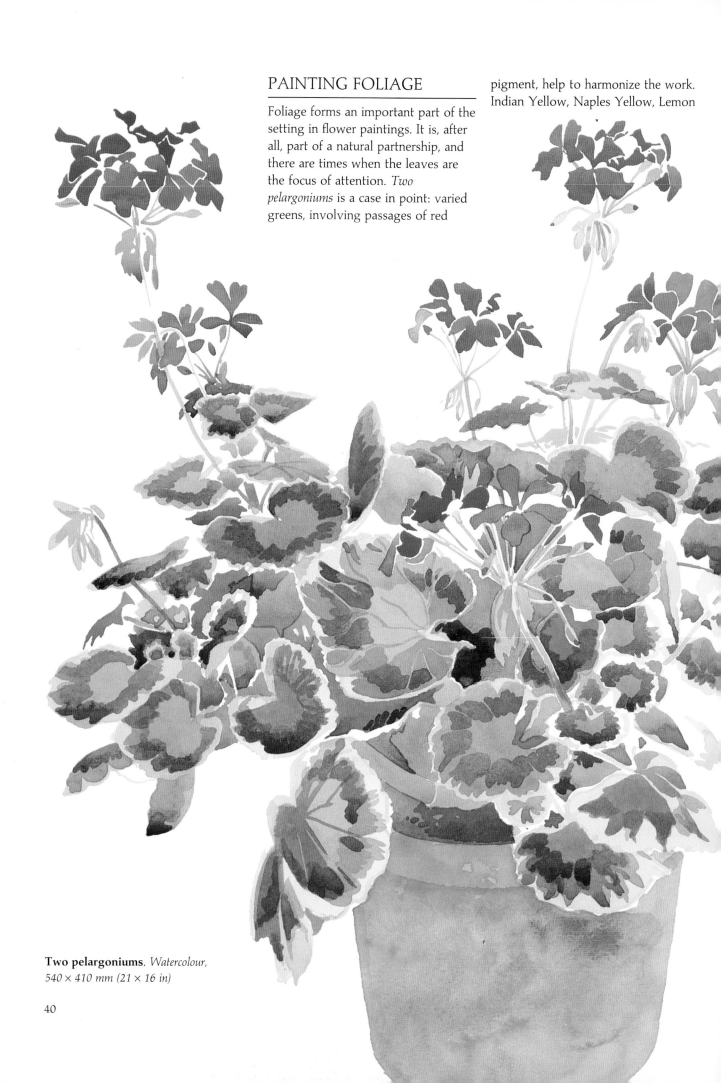

PAINTING FOLIAGE

Foliage forms an important part of the setting in flower paintings. It is, after all, part of a natural partnership, and there are times when the leaves are the focus of attention. *Two pelargoniums* is a case in point: varied greens, involving passages of red pigment, help to harmonize the work. Indian Yellow, Naples Yellow, Lemon

Two pelargoniums. *Watercolour, 540 × 410 mm (21 × 16 in)*

40

Yellow Pale, Cerulean Blue, Cobalt
Blue, Burnt Sienna and Cadmium Red
Deep comprised the palette.

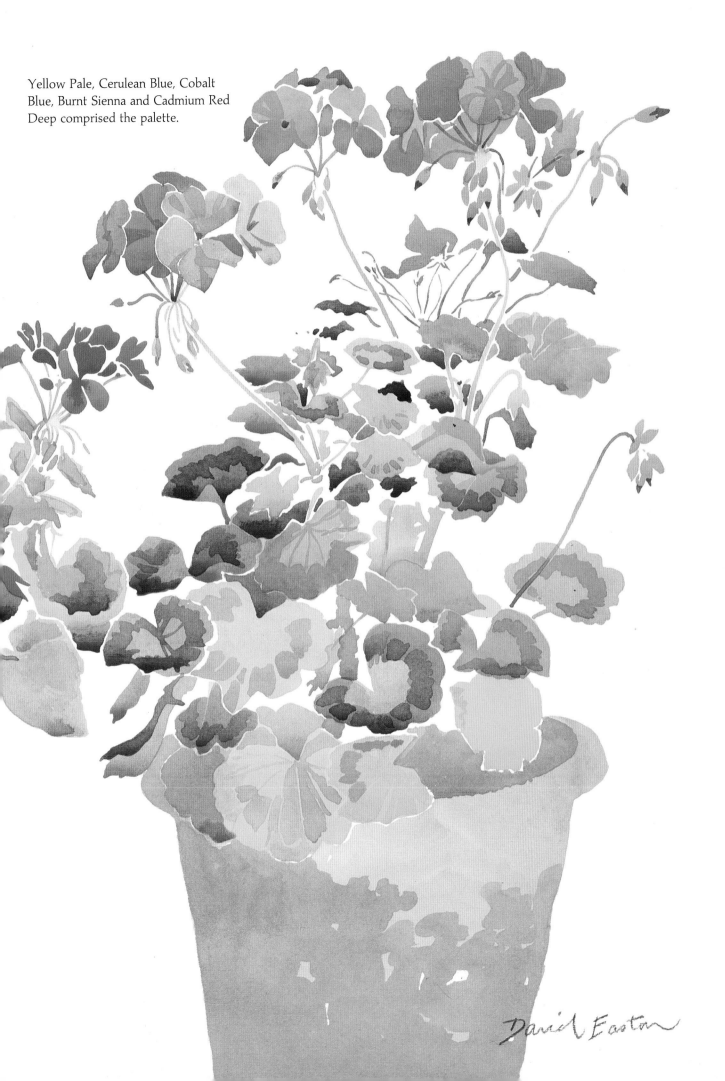

David Easton

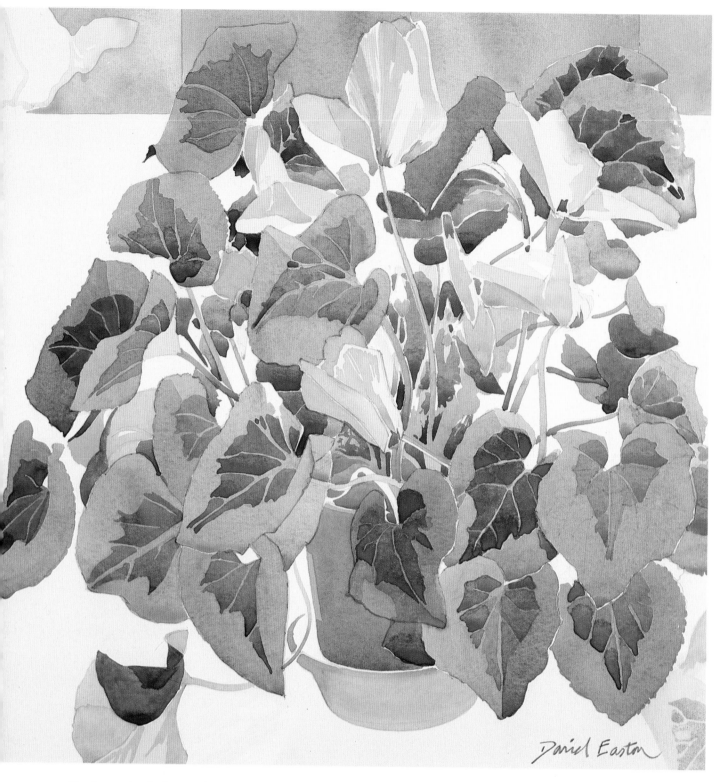

The leaves in *Cyclamen plant* (above) consist of Cerulean Blue, Raw Sienna and Winsor Yellow, with a thin wash of Alizarin Crimson over some shadow areas. The sketchbook

Cyclamen plant. *Watercolour, 305 × 305 mm (12 × 12 in)*

Cyclamen and fans (detail).
*155 × 205 mm (6 × 8 in). The full painting
is shown on page 87*

Cyclamen leaves. *Pencil and watercolour,
255 × 205 mm (10 × 8 in)*

cyclamen study (left), made up of
Cerulean Blue and various pale
yellows, explores the pattern of the
variegated leaves. The very simplified
foliage shown in the detail from
Cyclamen and fans (above) is
surrounded by complementary
colours. The leaves are picked out
against each other by tone changes.
(See page 87 for the full painting.)

Foliage can, of course, be treated in
much more impressionistic ways, as in
some of the wet-in-wet works shown
earlier. The type of relationship that is
formed between flower and leaf is
something to consider when you are
setting up a studio subject.

In settings such as a garden, where
a flower border may present you with
a rich tapestry of growth, distinctions
between flower and foliage become
complicated. You certainly need to
concentrate in order to make sense of
such a challenging subject. I have
even tried propping a large mount
directly in front of the scene;
composing through a viewfinder in
this way can be an effective aid.

DRAWING AND COMPOSITION

We are often told that watercolour is the most difficult painting medium, because it is the most demanding in terms of draughtsmanship. This can be rather daunting, especially if drawing is thought of in the limited sense of mere manual dexterity with a pencil.

Such ideas may have been encouraged by tutors in past times, when pupils were often expected to gain a proficiency with graphite before being allowed to paint. This often resulted in a high degree of technical excellence being achieved, but at some cost to creativity. Most art tutors would now encourage their students to draw with a wide range of implements, including the brush, helping to bridge the drawing-to-painting gap.

Carnations. *Pencil, 355 × 460 mm (14 × 18 in)*

David Easton

Carnations. *Watercolour, 355 × 460 mm (14 × 18 in)*

Another important factor comes into play when your line drawing is made with a pen or brush, rather than in pencil. You can only make changes to the drawing by *adding* marks, and this makes you look more closely. Pen- and brush-drawing are, therefore, very good training for the eye, and often produce more expressive work. Experience of drawing in this way can also lead to more characterful work with the pencil, when the habit of looking is established. A pencil drawing made to underpin a water-colour painting should be light, and flexible enough to allow the brush to make the decisive shapes. The pencil can establish placing, proportions, directions and rhythms with some freedom, while the shapes of petals, stems and leaves are better rendered with the brush (look, for example, at the paintings on pages 16–17).

The pencil line can be an integral part of the image, working in counterpoint to the brushmarks; or, having served its purpose, it can become completely lost under the paint. In any case, I would counsel against erasing pencil marks at any time before the work is completed and dry, and even then it is seldom necessary.

MOVEMENT

When we think of movement in drawing, we can consider two aspects. Firstly, a drawing can possess movement in the way it invites the eye to follow lines, rhythms and patterns through the work. Plants, as well as landscapes and figures, certainly contain these elements, and they can be accentuated through the process of drawing.

The pencil drawing of lilies shown here has a flow across the page. It is drawn with a hard pencil on a smooth Arches paper, which enhances the linear clarity. The few areas of shading emphasize the direction of growth. The contours of the forms are not continuous; the edges are given selective emphasis because this is how we see them. The eye of the viewer makes the connections where continuity is only implied. Compare

Lilies. *Pencil, actual size*

the lily drawing with the gouache painting on page 36 (top). It was created from the same subject, viewed from the other side.

The second aspect of movement is about time and change. These irises and poppies were drawn while they were opening and taking on new forms. On the iris sketches I have used arrows to remind me of the sequence at various points. Sometimes the changes happen too quickly for a

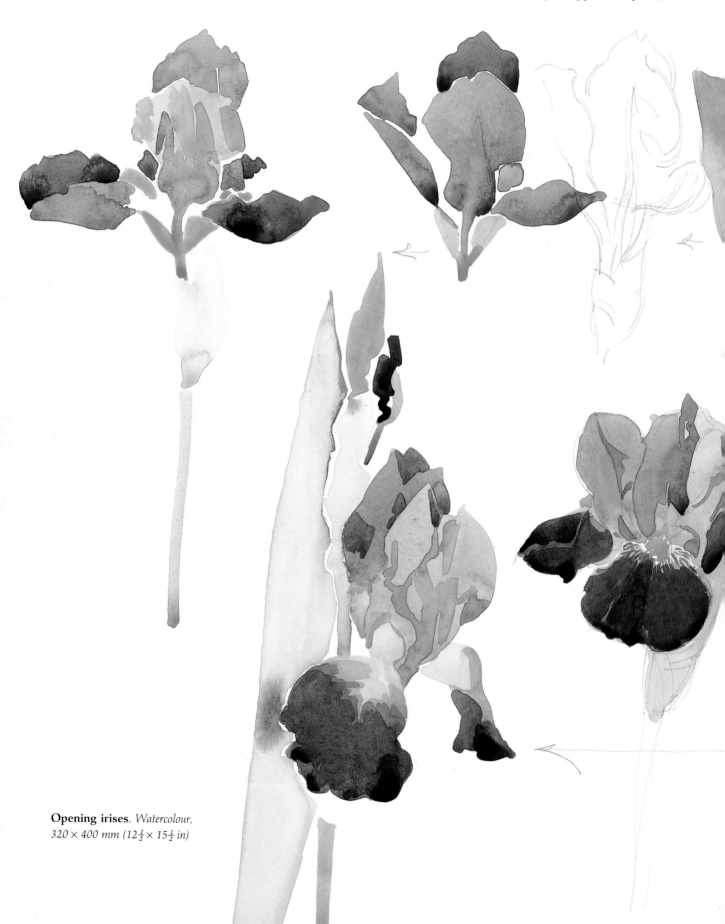

Opening irises. *Watercolour,*
320 × 400 mm (12½ × 15½ in)

drawing to define any specific moment, but a series such as this is helpful in gaining an understanding of the subject for subsequent works.

(Right) **Opening poppies**. *Pencil and oil pastel, 305 × 102 mm (12 × 4 in)*

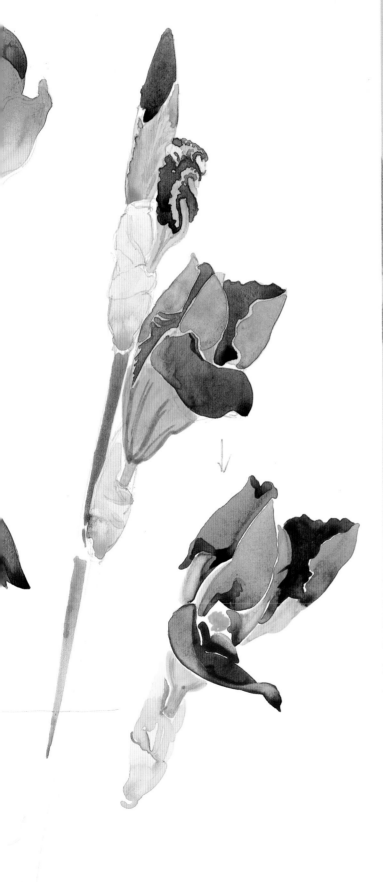

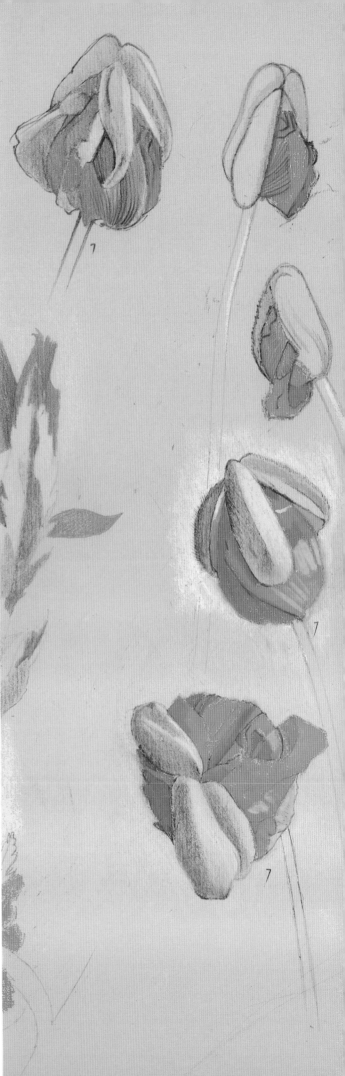

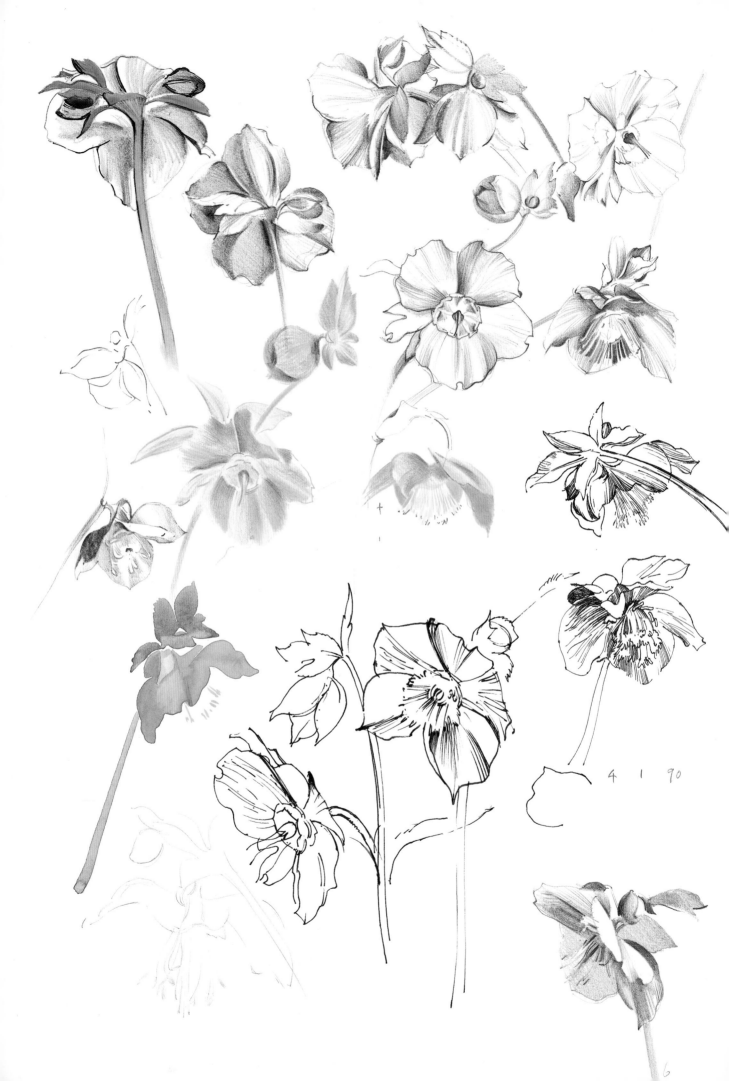

4 1 90

6

KEEPING A SKETCHBOOK

The only way to improve your drawing is to do a lot of it. A sketchbook is a vital item for any artist. It should be notebook, resource, visual diary and constant companion. This is what art-college students are told, and it applies to anyone who means business.

Apart from all that, a sketchbook is a great pleasure to keep and work with. I love to open the spread of a book, and to explore the qualities and characteristics of flowers, as well as other subjects, seeking to capture something of their essence in various media. Pages that might include pencil, pen, crayon, pastel and various types of paint can be so much livelier than a book full of similar renditions in only one medium. The more you explore, the more you are likely to find inspired juxtapositions of form, leading to ideas for composing a painting. I often find that an old sketchbook will contain the missing clue when I am composing a new picture from studies.

Many well-observed and quickly noted studies should form the core of the sketchbook. You can allow yourself the occasional set-piece, but a sketchbook is for use rather than for show. In addition to making studies of individual flowers, it is equally valuable to set down ideas for complete paintings.

Sketchbooks come in a bewildering array of types and sizes. My preference is for a white cartridge, such as the Lyndhurst range. I have several sizes from this spiral-bound range, but for the pocket I would go for a bound book with hard covers. A book of assorted pastel papers makes an exhilarating change. It gives you a chance to make the most of your opaque media, and offers a headstart

Hellebores. *Studies in pencil and crayon, 460 × 330 mm (18 × 13 in)*

when you choose a colour which suits the subject.

I think there are positive benefits to be derived from giving yourself a change from the seductive watercolour-paper surface when you make sketchbook studies. When working in a watercolour book there is a danger of lapsing into watercolour clichés, paying more attention to technique on the page than to the attributes you are seeking to discover in the subject matter.

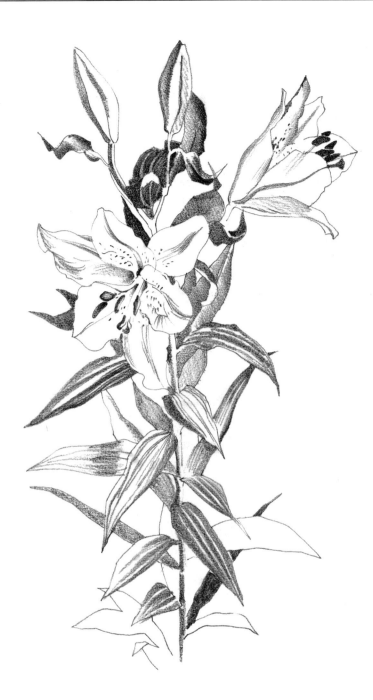

Lilies. *Soft pencil, 330 × 180 mm (13 × 7 in)*

What I am suggesting here is that some of every artist's time should be spent on studies, especially drawings. It is indeed sad when the pressure to produce paintings one after another leaves the artist with no time for research and development.

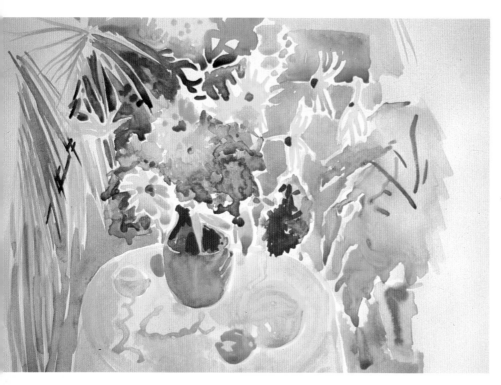

Compositional study. *Watercolour,*
230 × 280 mm (9 × 11 in)

Compositional sketches are a very useful way of exploring ideas. Usually made on a small scale, they can be the means by which the painter sorts out the proportions, the placing of the main shapes and focal areas, and the colour scheme.

I make two types of compositional study. The first is made in front of the subject, and is often the prelude to a painting. The second is made to organize works which are composed of separate studies, and involves more of an imaginative input. It may deal

(Below) **Compositional study**.
Watercolour, 535 × 410 mm (21 × 15 in)

(Above) **Poppy composition**. *Acrylic,*
410 × 535 mm (15 × 21 in)

COMPOSITION

All painting is composed. The term refers to the form that a work takes, and concerns the way in which it is structured within the chosen format. Some artists favour the same format for all their works, which is limiting. The size and proportion should be a matter of positive choice for each work, based on what is needed to deliver the idea.

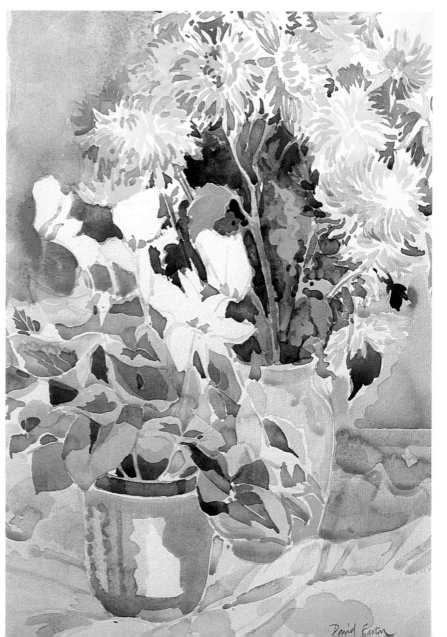

Sketches. (Right) pencil and watercolour,
230 × 305 mm (9 × 12 in)

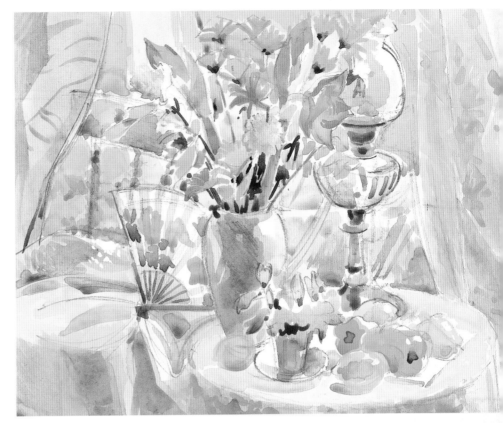

with the problems of transplanting an observed study into a setting which is part real and part imaginary.

The sketches on this page were made in front of the subject. They included very rapid notes about how shapes might be related to the rectangle, and some more elaborate studies which became paintings. Paintings are not replicas of reality. With the exception of *trompe l'oeil* works, they are not trying to *be* the real substance of the subject. The devices that painters use to suggest space, movement, volume and other illusions are not designed to fool anyone into regarding a picture as anything but a construct of paint and paper.

A painting might indeed invite the eye to journey *around* the work. These journeys may be through into distance, or they can be across the picture plane. The latter is true of many contemporary works, and is a feature of Oriental and Middle Eastern traditions.

When inventing settings which involve the evocation of space, several devices could come into play.

(Below) pencil and watercolour, each
102 × 128 mm (4 × 5 in)

Aerial (or colour/tone) perspective, linear perspective and scale come most readily to mind. A tension exists here. How much is to be logical (could such a view exist?) and how much is subordinated to design considerations in the abstract? This problem is more acute when the various ingredients of the work are clearly depicted. I much prefer to employ some ambiguity. I like to give

the viewer some work to do, because I enjoy this aspect in paintings generally. It is a quality that brings you back to a painting again and again, each time finding that it offers fresh interest.

A calculated freedom of handling might be appropriate, but do not confuse this with looseness. However free or impressionistic a painting may be, it should always have an

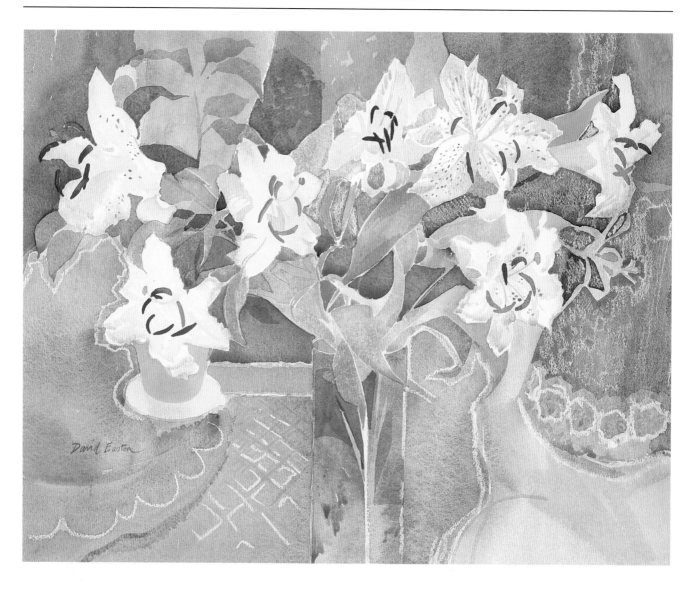

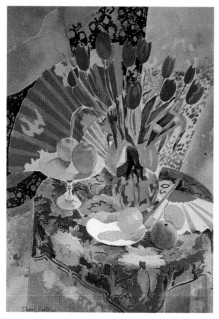

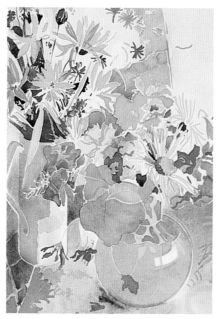

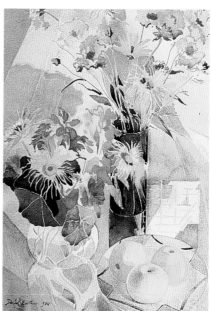

Eight watercolour compositions

underlying structure, albeit one that arrives late in the day.

I see composition as the process of building a work shape by shape, to the point where it may be regarded as a complete entity. The feature of this type of painting is the judgement that the painter has to exercise throughout the work, regarding the distribution of the flowers and their relationship with the paper. A coloured paper can suggest a spatial context. White is more demanding: although it is an enhancer of colour, it cannot be allowed to overpower the image. The acid test of a well-composed image on the page is that it would lose by any addition to, or subtraction from, the edges. It has to feel right in the space.

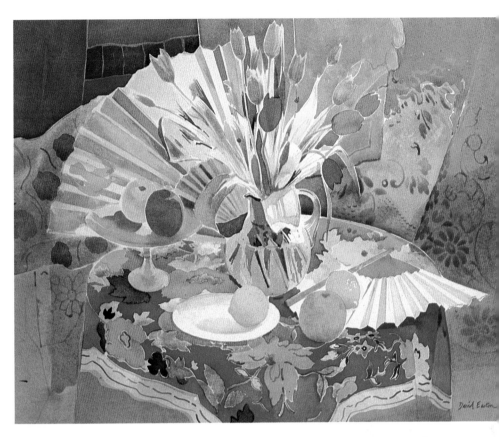

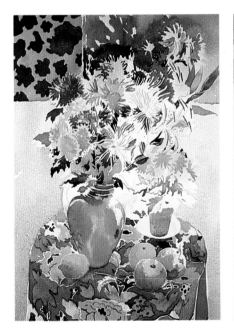

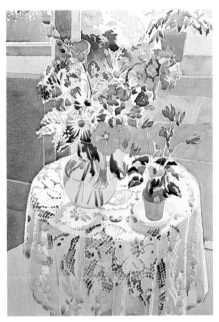

 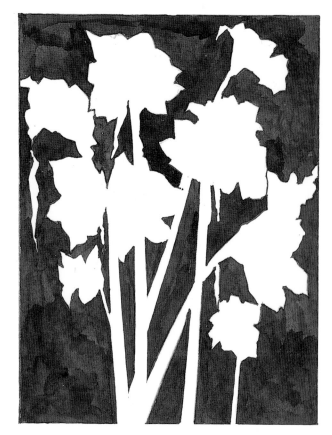

Figure 70 *Diagram of negative and positive shapes*

The diagrams above draw attention to positive and negative shapes. They are equally important. The amaryllis flowers and stems are grouped with the enclosed shapes of white paper very carefully considered.

Orchids (overleaf) is in similar vein to *Amaryllis* (opposite), but is more of a montage and does not make as compact an image. The botanical illustrator would go for a more detailed analysis of the component parts of the plant, but I have again become interested in the shapes between them. Notice the white area trapped between the two larger flower stems. It seems to have something of the character of the individual flower shapes in negative form. This is an idea that I would like to explore in future studies. Naples Yellow and Lemon Yellow Hue underpin all the colours, and Brown Madder Alizarin and Alizarin Crimson complete the flowers.

Tulips on pages 92–3 is another painting in which the negative shapes of a white-paper background form an interesting relationship with the flower subject.

Amaryllis. *Watercolour, 710 × 540 mm (28 × 21 in). A detail is shown on page 32*

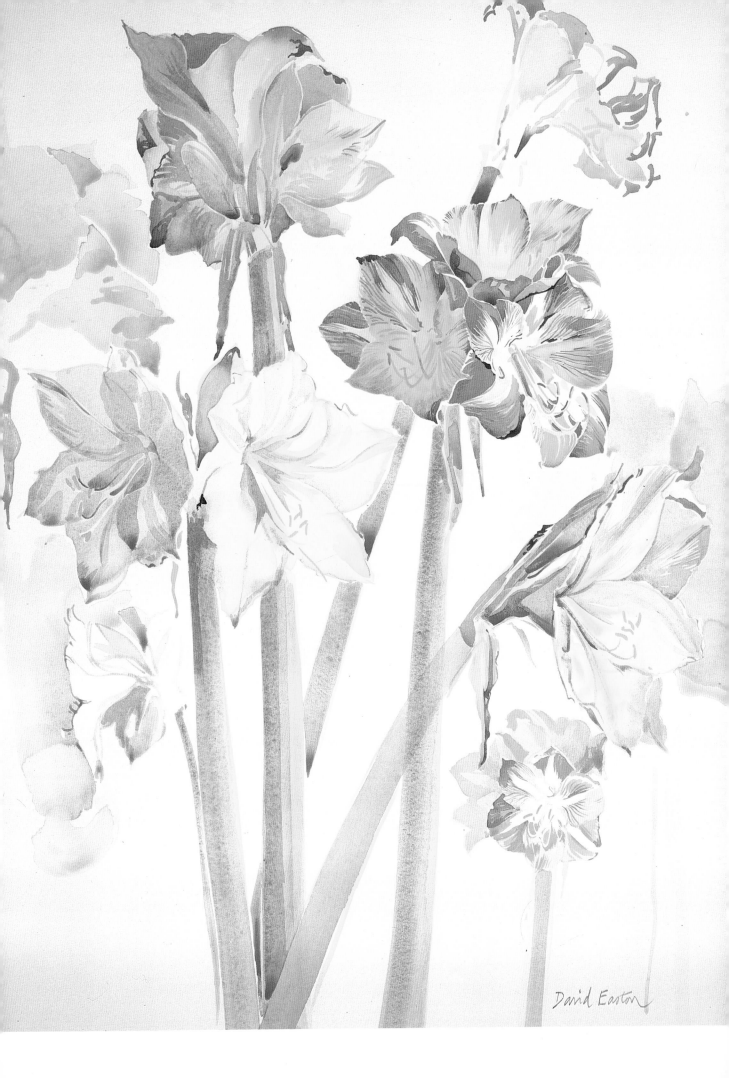

David Easton

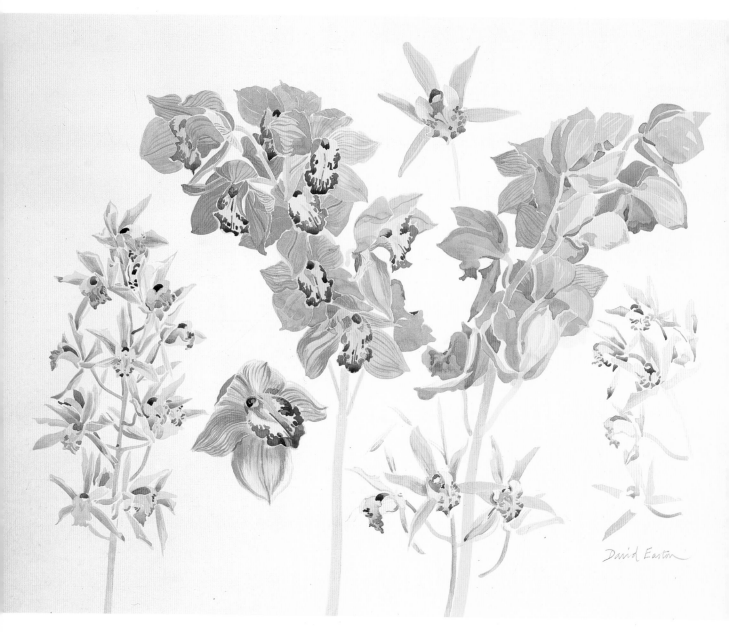

Orchids. *Watercolour, 510 × 760 mm*
(20 × 30 in)

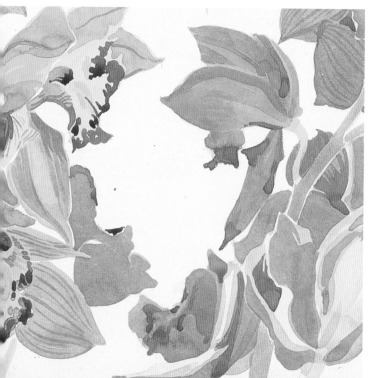

Orchids *(detail of above). 190 × 190 mm*
($7\frac{1}{2}$ × $7\frac{1}{2}$ in)

THEMES AND VARIATIONS (1)

Many notable artists have been obsessed with a fairly narrow field of interest throughout their careers. I think that a series of mini-obsessions can be a good way of progressing for artists at any level. For the flower painter, it makes sense for several reasons.

In the first place, the activity is greatly influenced by the seasons and the availability of plant material. It therefore makes economic sense to use your subject to the full. Secondly, the experience gained from each piece of work can be carried forward to subsequent paintings, while it is fresh in the mind. More important, from the developmental standpoint, is the extension of the artist's creative resources which can result from this way of working. The more you explore, the more you notice and the more you learn.

Most creative people find that inspiration ebbs and flows, rather than coming in a steady stream. When an idea captures your imagination, don't assume that you can say it all in one painting. Learn to see it as the next vein to be mined.

Size and proportion

It may prove rewarding to carry out variations within the same format. You should, however, be prepared to consider working on a different scale or proportion, at least from time to time. Your subject may well suggest a suitable shape. You will see that I have favoured a square format for several works in this book; it seems to be a shape which makes me think about composition from the outset.

The support

Papers come in a variety of surfaces and colours (see page 124). Each can be exploited positively, and will bring fresh impetus to your work. While there are undoubted benefits to be gained from thorough acquaintance with a paper, an unfamiliar product can be exhilarating.

Colour

To work within a scheme, possibly limiting the palette to just a few pigments, can be rewarding. Try deviating a little from the colours that you usually favour. This is not to throw the whole balance overboard, but, by introducing – one at a time – an unfamiliar blue, green or red pigment, for example, you will extend your experience of colour-mixing. Remember, too, that an effective painting often has a blend of warm and cold colours, but with one polarity dominant.

Techniques

Bear in mind that the subject may suggest a particular approach. Set out to put your emphasis on the shape, texture, tonal contrast, colour richness or other attributes that you may perceive in the subject. The methods you use should be prompted by this. Techniques can become so obtrusive that they overwhelm the image, rather than serving to deliver the idea. I use wet-in-wet techniques comparatively rarely, because distinct shapes and edges appeal to me more than diffused atmosphere.

Learning from the work

Give yourself a little time to absorb each piece of work. You may find it very helpful to have recent work around for a while, in order to establish some sort of continuity. It is, of course, necessary to initiate something totally new at times, but it can be hard to work in a vacuum. As you look at your paintings over a period of a few days, you will develop attitudes to them. Self-criticism is a vital part of learning: never destroy your work in the heat of the moment! You can learn as much from your flawed work as from your winners.

It is also feasible to 'rescue' a failure. Transparent watercolours can evolve into mixed-media pieces, in which you might include any other water-based paint, or even pastels. It is, after all, the result and the experience gained that matter, rather than some notion of purity of technique.

AUTUMN

This set of paintings (this page to page 65) was produced in October. Some flowers from the garden were added to a few bought chrysanthemums, and the setting adjusted between each work. In some cases, I made a sketchbook study to establish the composition and to give me the confidence to start directly with brush-drawing. The variations included the choice of papers. The paintings on pages 63 and 64 are on Fabriano Roma, which is available in several colours. It is a pastel paper, but I enjoy the texture and colour as an occasional change. In these two works the paper colours were of a deep enough tonality to require some body colour (watercolour mixed with white) to heighten the light passages.

The common factors are size and proportion, the viewpoint, and some of the flowers, fans and containers. If you compare one element from each painting – the table top for example – you will see that it occupies much the same area in each work. The variation lies in the treatment, and in the distribution of the objects. To achieve compositional balance, the flower colours are echoed in objects on the table. Another device is to use a second, smaller container which, viewed from above, brings the floral elements cascading diagonally down the page.

Flowers/peppers/fans (left) was painted with many small brushstrokes, in response to the way the light seemed to fragment and filter through the flowers. The second version (opposite) was seen more in terms of broad shapes, with a simplified structure. In both cases I sought to make the saturated colours sing by setting them together in close tonal values.

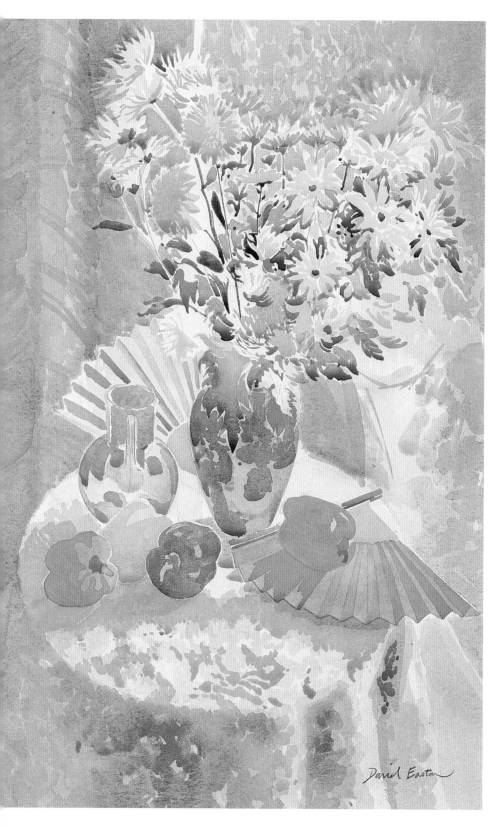

Flowers/peppers/fans. *Watercolour, 510 × 330 mm (20 × 13 in). A detail is shown on page 21*

Flowers/peppers/fans (2).
Watercolour, 510 × 330 mm
(20 × 13 in)

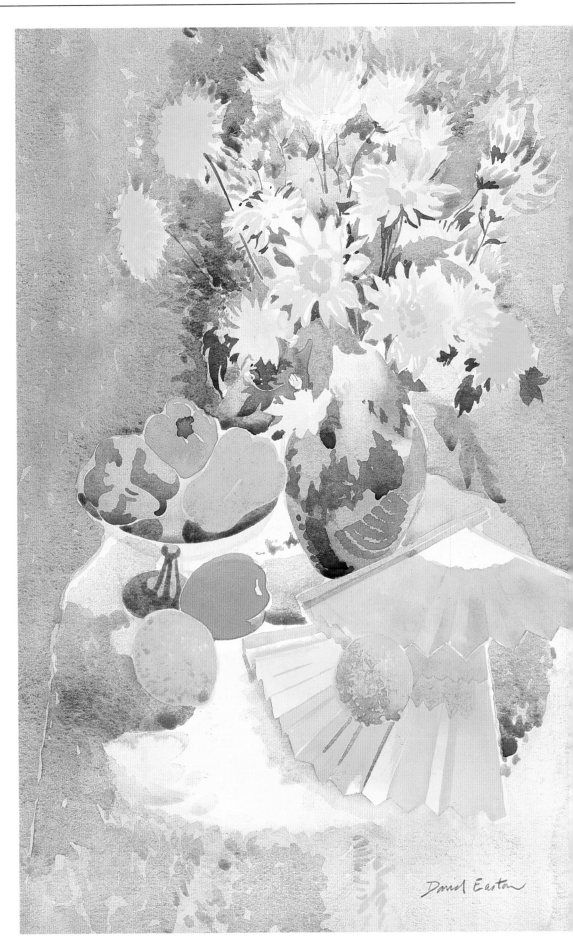

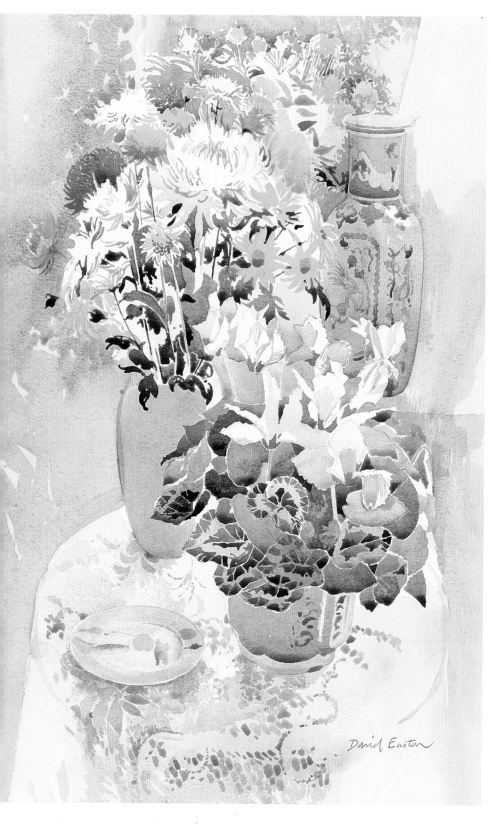

Plant and flowers (left) was absorbing to paint. I started by painting the cyclamen flowers in pale mauve (mixed from Cobalt Blue and Alizarin Crimson), washing in the shadow shapes, and keying the edges lightly to guide subsequent colours. (A detail of this painting is shown on page 8.) I often find that, despite the advice I sometimes give about working 'broad to fine', I am doing the opposite! Here I am clearly going from fine detail to broader shapes, as the painting explodes away from the carefully placed flowers.

Two points about this. Firstly, the painting was planned in a sketchbook beforehand, so the general positioning of the flowers was already established. Secondly, although they were carefully observed, the finer details were still painted with fluid and direct strokes. If I had resorted to laborious pencil drawing at any stage, the work would have lost any life it may possess.

The colours employed in the three works on white papers were Alizarin Crimson, Cobalt Blue, Cerulean Blue, Lemon Yellow, Aurora Yellow, Raw Sienna, and small amounts of French Ultramarine, Cadmium Red, Viridian and Pthalogrin (Schminke). The background washes were all composed of permutations of these colours, contributing to the harmony of each painting.

Plant and flowers. *Watercolour, 510 × 330 mm (20 × 13 in). A detail is shown on page 8*

POPPIES

Oriental poppies have been a special subject for me in recent years, and these dramatic flowers make eye-catching images. In addition to the shapes of the flowers themselves, my interest lies in creating compositions

Poppy studies. *Watercolour, 410 × 460 mm (16 × 18 in)*

Poppies: *the finished painting. Watercolour, 435 × 585 mm (17 × 23 in). A detail is shown on page 16*

with contrasting and/or harmonizing colours. The colours chosen to accompany the red-orange blooms are prompted by the actual setting, but are always modified and adjusted in the interests of the overall design.

I make a lot of sketches in the garden, and from material brought into the studio. Some of the individual flower studies on pages 69 and 71, made at various times, have been brought together in studio-based paintings. The sketchbook spread on the left has proved to be useful, because it shows groupings of flowers and foliage. It is obviously a more natural progression to move from such a sketch to a composition. I have used this arrangement in two very different ways, as you will see in *Poppies* (above), which is a more organized version of the original sketch, and in *Poppy pathway* (overleaf). *Poppies* was painted on a Not surface, and a detail of the brushwork appears on page 16.

Poppy pathway is a more elaborate composition with an imaginary garden setting, derived in part from a photograph. This was painted on hot-pressed paper, and gouache has been used over much of the work. I resorted to this medium because some of the tones in the setting had become too dark. The opaque colour has been hatched and applied in a variety of broken textures over most of the painting, excepting the flowers, which remain transparent.

Poppy pathway. *Watercolour and gouache, 540 × 540 mm (21 × 21 in)*

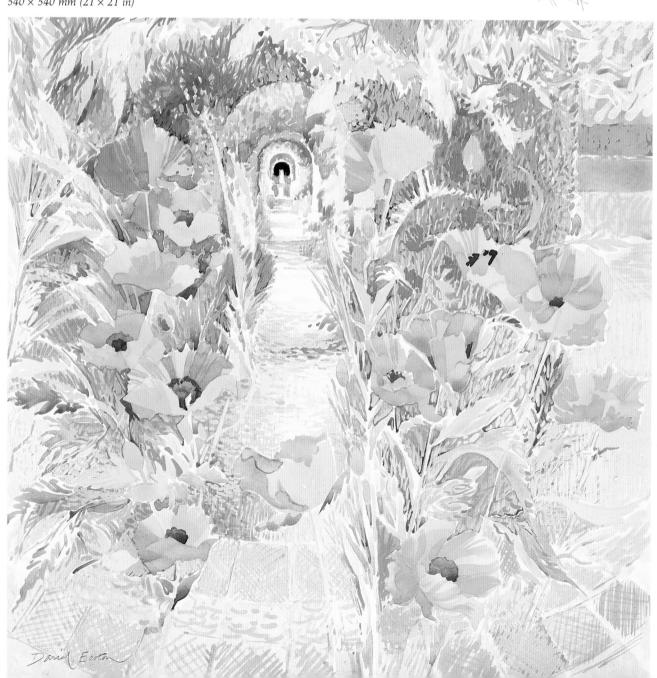

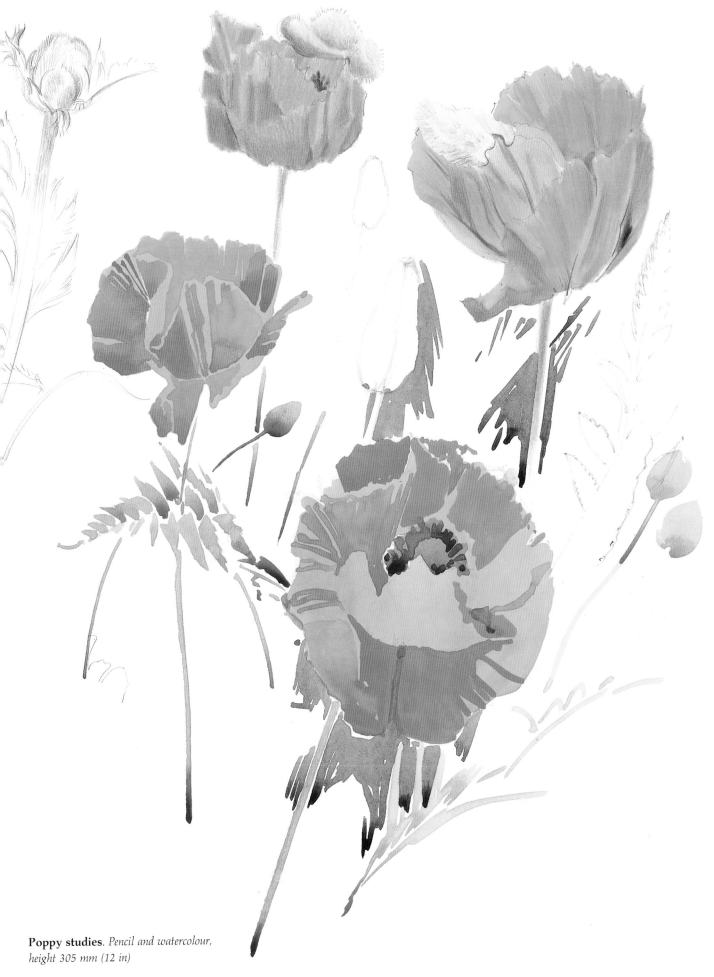

Poppy studies. *Pencil and watercolour,*
height 305 mm (12 in)

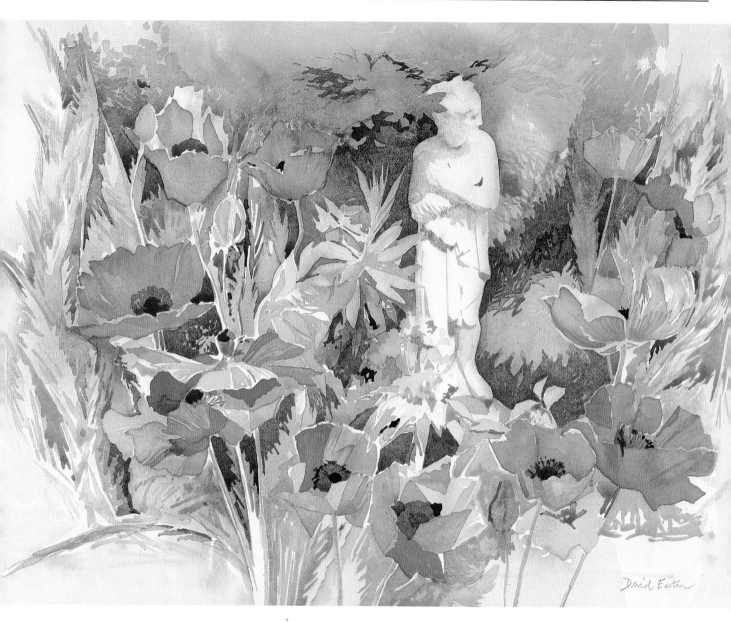

Poppies and statue. *Watercolour, 510 × 760 mm (20 × 30 in)*

Poppies and statue (above) was composed from sketches. The statue is the focal point, and was adapted from my photograph, lightly drawn with a pencil at first. The flowers form an encircling garland. White is reserved for some crisp edges, which contrast with softer transitions, and the colour scheme takes up the yellowing foliage and complementary violets.

Movements are set up among the flowers by means of contrasting directions and scale of foliage. This painting was carried out on a Not paper, with enough tooth to give granular texture where the pigments separate on and around the statue.

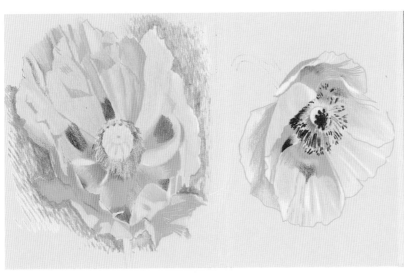
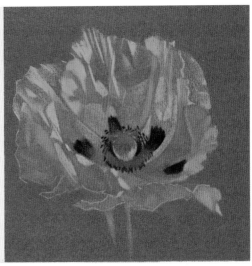

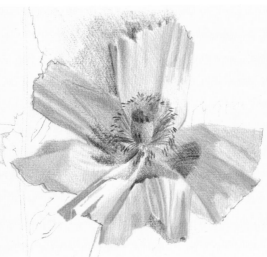
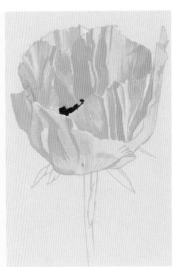

Six poppy studies. Mixed media,
367 × 485 mm (14½ × 19 in)

Poppy study. *Pencil and crayon,*
255 × 355 mm (10 × 14 in)

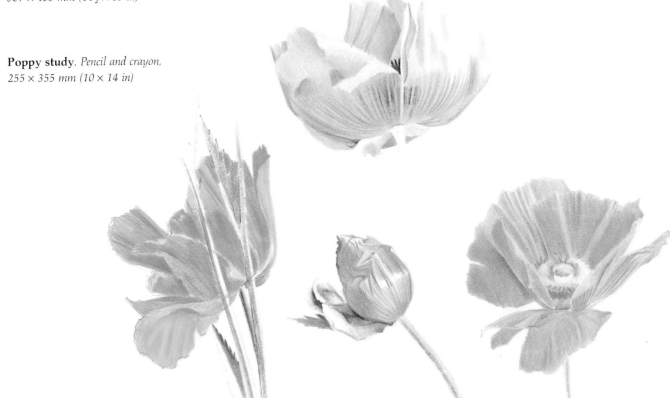

Poppies and yellow flags is a free grouping, painted directly from a bunch of the flowers brought in from the garden in June. A detail is shown and described on page 29. The flowers were painted first, and the foliage put in selectively when the flowers were dry. A few tones placed between them served to create sub-groupings and to enhance the flags. The range of colour in the poppies goes from a full Cadmium Red Deep, through orange, to a pale salmon-pink. The same yellows are present in the poppies, flags and leaves.

The overall shape is given a lively edge by the diversity of flower scale and form. Decisions about emphasis are often made instinctively; sometimes the very first brush-drawn shape is enough, without elaboration. The choices about where to give definition are made partly according to the way each part is seen, and partly in the context of how the shapes and tones interrelate. Dark accents of poppy markings are a composition in themselves, taking the eye across the picture plane.

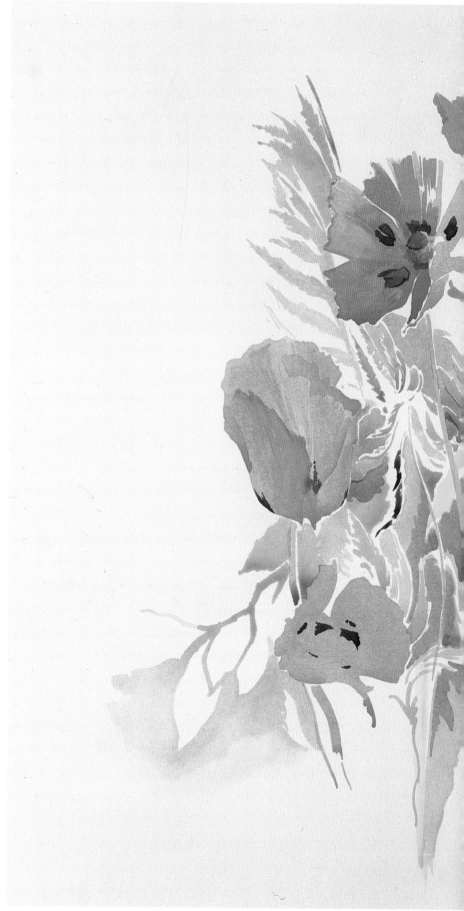

Poppies and yellow flags. *Watercolour, 435 × 660 mm (17 × 26 in). A detail is shown on page 29*

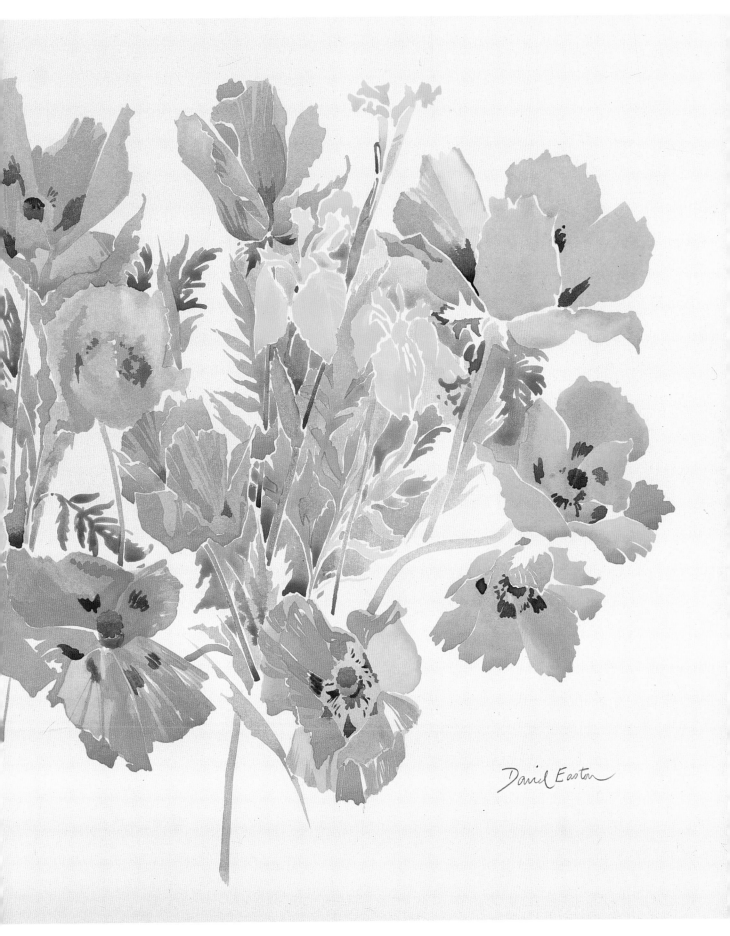

David Easton

Poppies and irises was painted from a large bunch in a container. The flowers and much of the foliage were painted in one session. After a few days, the paper was immersed in a bath of water and stretched on to a board, secured along the edges with brown gum strip.

While the surface was damp, further foliage shapes were added, and, as the paper dried, more saturated reds and greens were dropped or laid into the darker passages. These methods gave a greater richness to the work, extending the range of colour intensity and the variety of mark from soft to more defined.

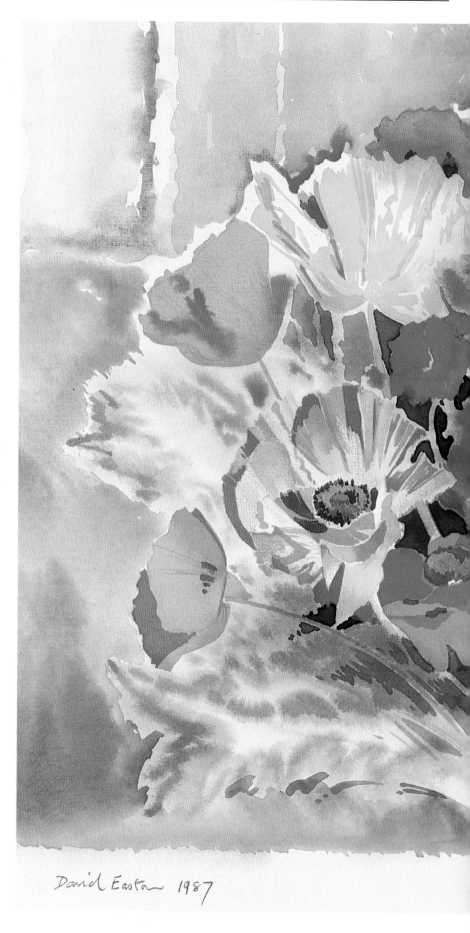

Poppies and irises. *Watercolour, 410 × 560 mm (16 × 22 in)*

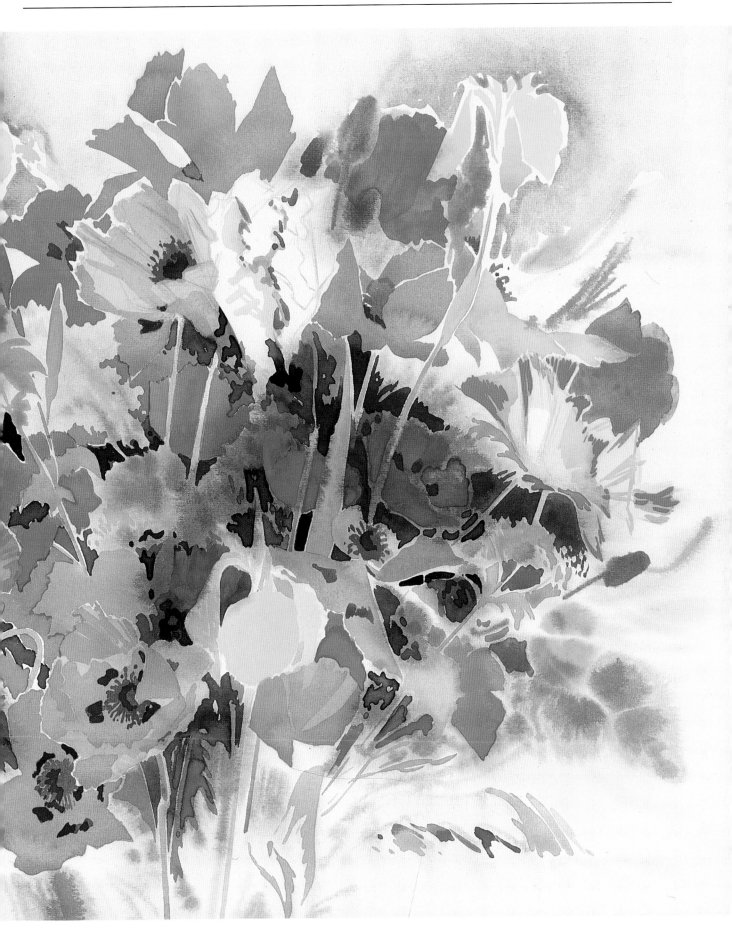

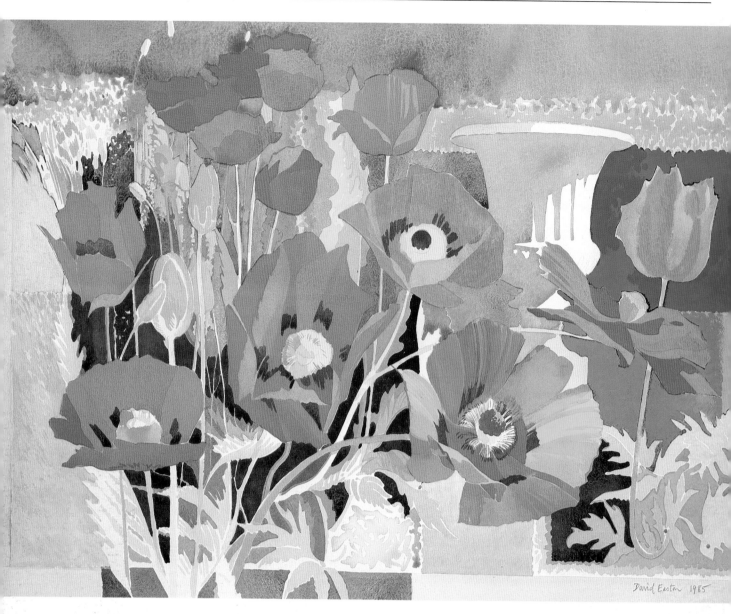

Poppies and garden urn. *Acrylic, 410 × 560 mm (16 × 22 in)*

The two poppy paintings shown here were given a more decorative treatment. Both were painted with acrylics, used in a transparent way at the outset, but subsequently developed with dense, saturated, opaque passages. Both were built up from studies.

Poppies and garden urn (above) is much flatter in treatment than the other garden-sited paintings. There is little here to convey depth, with the urn shape serving as a pattern element in the setting. Considerations of abstract design and pattern-making are given more importance than the creation of a specific garden setting in this work.

Poppies on blue (opposite) was organized with the help of the small compositional sketch shown above it. The acrylic pigments separate in a manner that differs quite distinctly from watercolour. This effect can be seen in the transparent tile shapes at the base of the painting.

Study for **Poppies on blue**. *Acrylic, 155 × 230 mm (6 × 9 in)*

Poppies on blue. *Acrylic, 410 × 560 mm (16 × 22 in)*

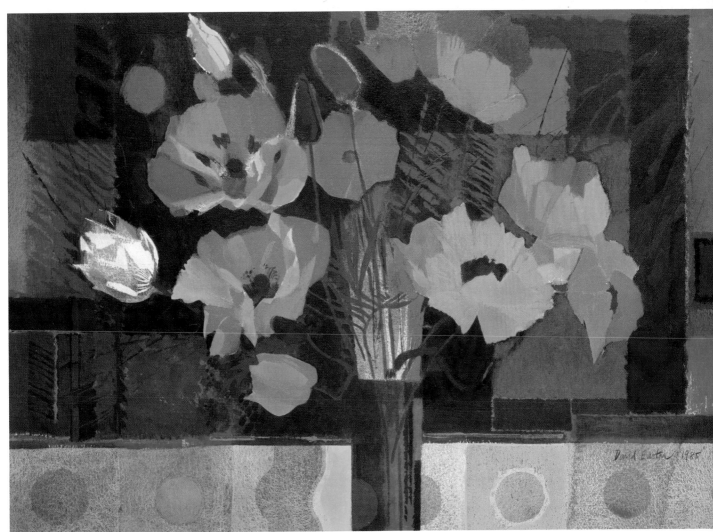

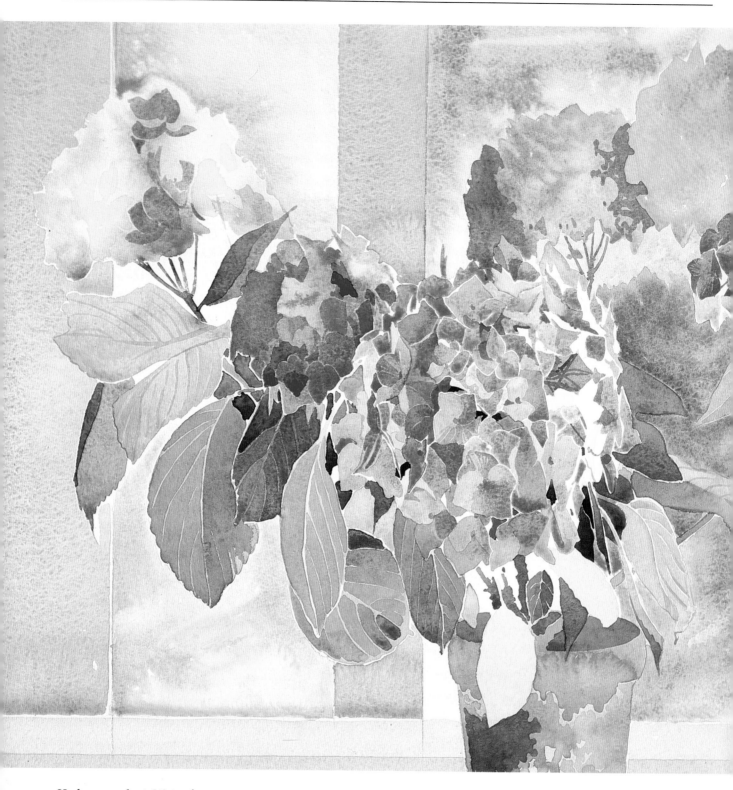

Hydrangea plant. *Watercolour,*
410 × 560 mm (16 × 22 in)

HYDRANGEAS

An appealing feature of hydrangeas as a subject for painting is the way that the tightly packed petals collect to form a compact flowerhead. In the case of the pot plant, the whole balance of flowerheads and foliage can be very satisfying. I buy at least one such plant each year, and produce a few studies before planting it out in the garden. I also keep a few dried specimens in the studio for sketching.

The paintings on pages 78–82 were painted from pot plants, and mostly include only a hint of a setting, because of the complexity of the plants themselves.

Hydrangea plant (left) has some very simple, flat and close-toned areas to allow the focus to stay with the more detailed parts. The geometry of this setting lightly sub-divides the picture plane, and acts as a stabilizing grid to support the heavy plant.

In *Pink hydrangeas* (below) the background was started wet-in-wet after some precise work on the plant. The colour scheme is basically formed from Alizarin Crimson and Brown Pink, with small amounts of a warm yellow and Cobalt Blue. Fragments of pattern on each side of the plant have a vertical emphasis, relieved by some angled edges.

Pink hydrangeas. *Watercolour and gouache, 410 × 560 mm (16 × 22 in)*

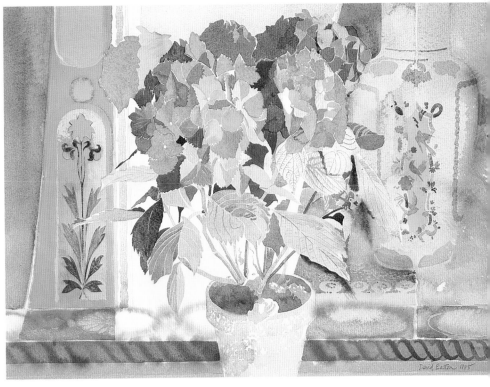

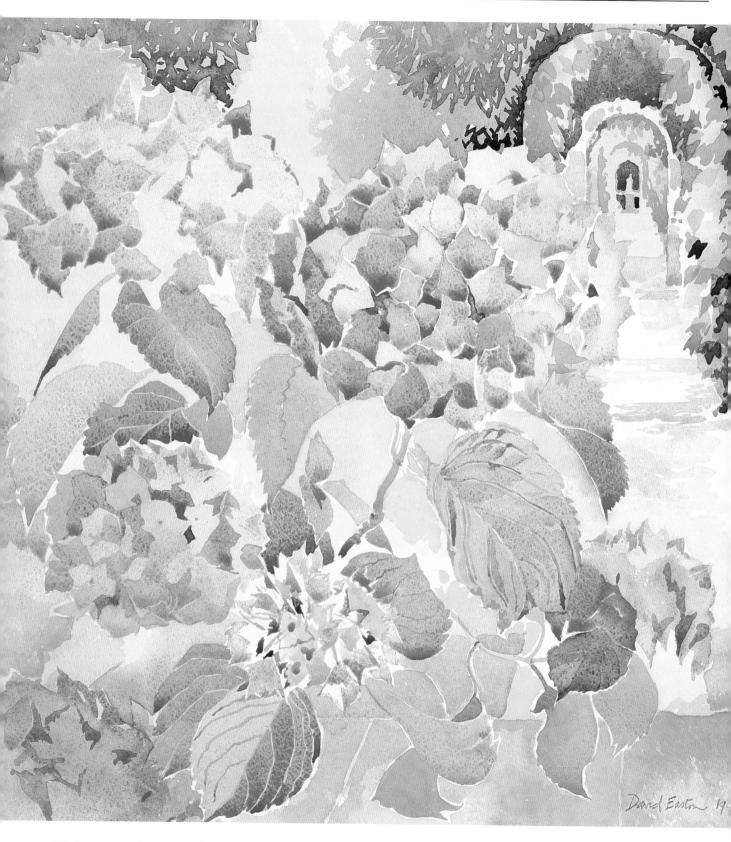

Hydrangea garden. *Watercolour,*
540 × 540 mm (21 × 21 in)

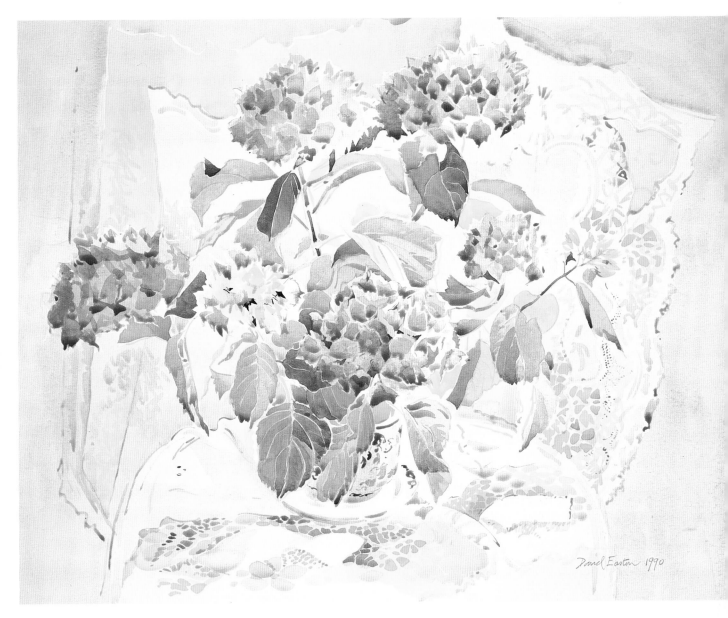

The square format of *Hydrangea garden* (left) presented a fresh set of compositional opportunities. The setting is from the same source as that used for the poppy painting on page 68. Here I was conscious of the need to key the corners, and thus give stability to the freely disposed flowers and leaves. The largest flower was constructed petal-by-petal on the Not surface, with French Ultramarine, Cerulean Blue and Alizarin Crimson providing some granular texture. I reserved edges of white paper in this,

and to a lesser extent in the other flowerheads. They were given a broader treatment, including some washes to pull them together. Compare this with the study on page 20, which was made at the same time but on a smoother paper.

Blue hydrangea plant (above) shows the plant poised in a container which becomes almost lost among the leaves. These leaves, together with the largest flowerhead, form the nucleus around which the satellite flowers are disposed.

Blue hydrangea plant. *Watercolour, 510 × 660 mm (20 × 26 in)*

81

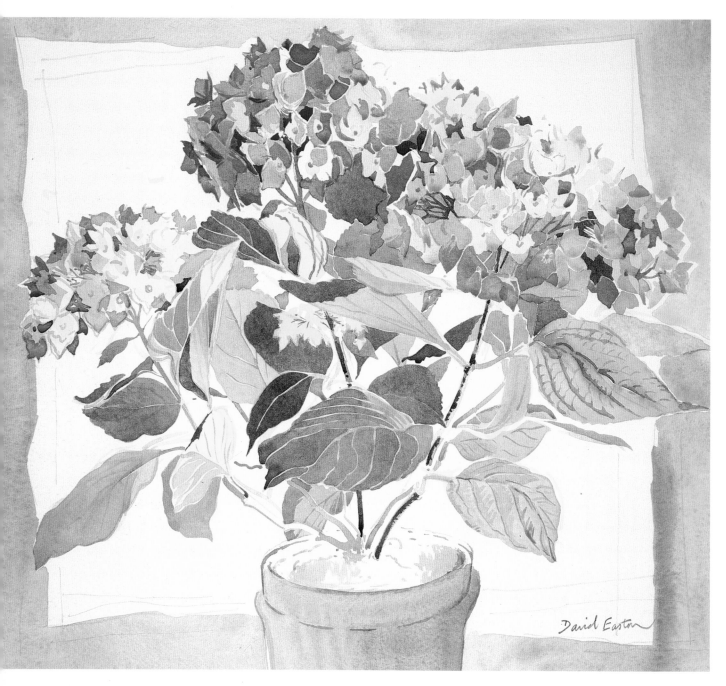

Blue hydrangea. *Watercolour,*
410 × 460 mm (16 × 18 in)

In *Blue hydrangea* (above) I was
more interested in the shapes of the
foliage, and chose the viewpoint
accordingly.

Cyclamen and rudbeckia (1).
Watercolour, 540 × 355 mm (21 × 14 in)

CYCLAMEN

Complementary colours and impressions

The two paintings on the right and overleaf were carried out with complementary colours in the general category of violet and yellow. Cool colours have been given more importance in the first of these by placing the group on a blue/violet fabric. It is better to avoid creating an equal balance of colour temperature.

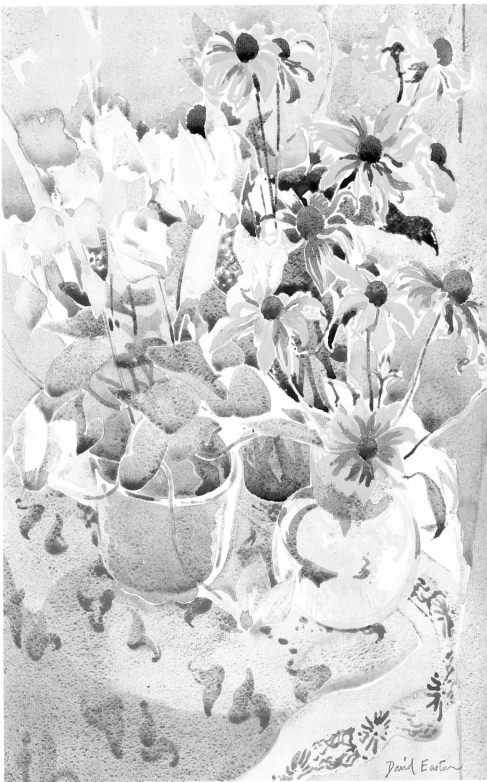

Cyclamen and rudbeckia (2).
Watercolour, 540 × 355 mm (21 × 14 in).
A detail is shown overleaf (bottom left)

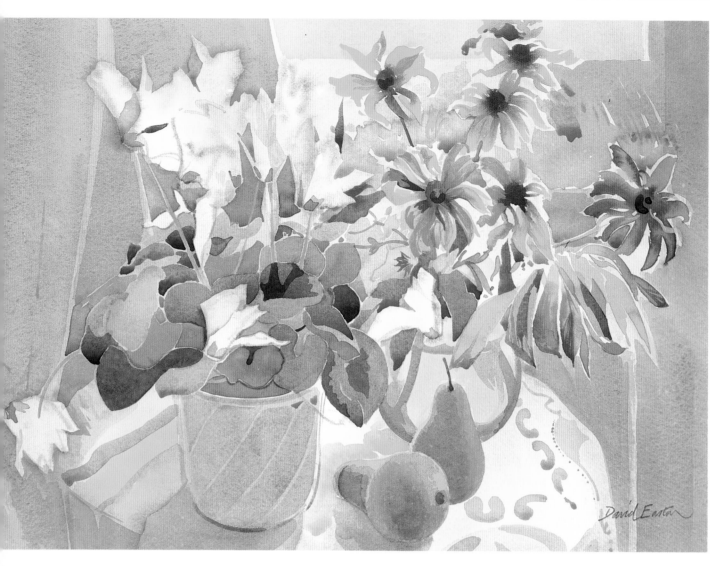

Cyclamen and rudbeckia (3).
Watercolour, 380 × 560 mm (15 × 22 in)

The painting above has a warmer feel, with its rich gold/ochre curtain. Both were painted in the same situation, as was the other, similar work shown on the previous page (top left).

The details of the cyclamen flowerheads (right) show that they were given a generalized and impressionistic treatment. Individual flowers have been absorbed into groups, with darker and warmer backgrounds providing the edge definition. They are allowed to fuse with their surroundings in the passages where they meet the same tone values.

The detail on the right clearly shows traces of a wet-in-wet

Cyclamen and rudbeckia (2) *(detail)*.
c. 265 × 230 mm (10½ × 9 in)

Cyclamen and rudbeckia (3) *(detail)*.
c. 265 × 230 mm (10½ × 9 in)

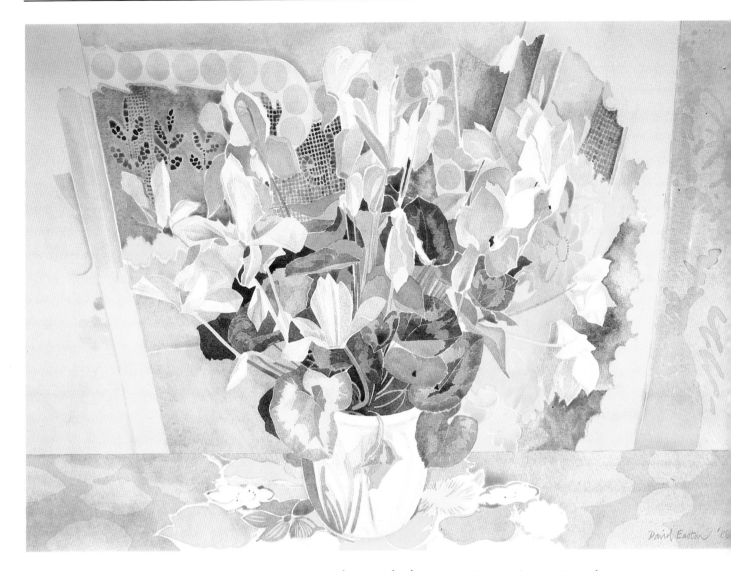

White cyclamen. *Watercolour, 460 × 660 mm (18 × 26 in). A detail is shown on page 23*

beginning. Apart from the contrast of warm against cold colour, there are fundamental differences in shape, form and overall tonal weight between these two flowers. In each painting the settings are made up of colours present in the flowers, which contributes to a simple, harmonious colour composition.

Centre stage or focal point

White cyclamen (above) creates a decorative pattern which extends into the setting. Carefully constructed in a limited range of colours, it again exemplifies the way in which colour temperature can play a vital role in painting. This is no less true in a painting that consists mainly of quiet, neutral colours.

Raw Sienna and Brown Pink oppose the mauve/greys which are made from muted reds and blues, and Burnt Sienna completes the palette. White paper is reserved for those parts of the flowers which received direct light, and for the pot container, the light shape of which is linked tonally with the largest leaf shape. The whole subject is lost and found against the fabrics of the setting, causing the eye of the viewer to move in and around the picture plane.

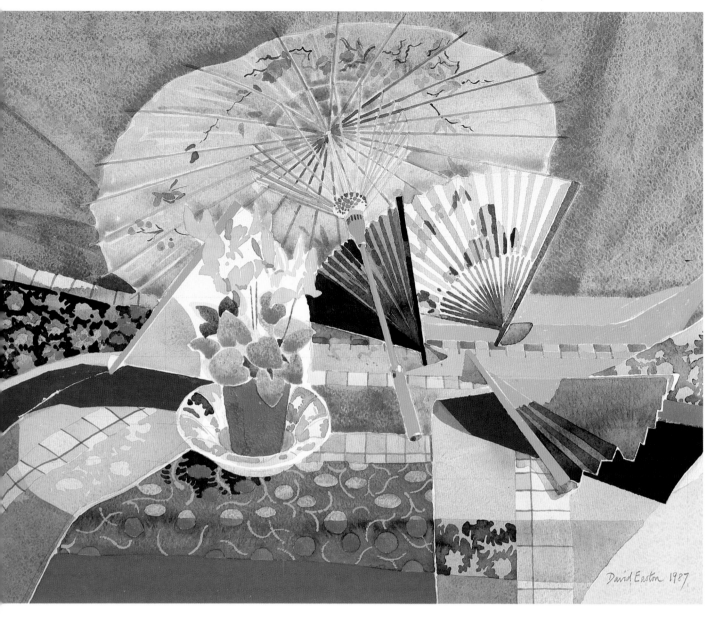

David Easton 1987

Parasol and fans. *Watercolour and gouache, 355 × 460 mm (14 × 18 in)*

Parasol and fans (above) is hardly a flower painting, but the cyclamen becomes the focus of interest as a note of natural form amongst the geometry. Many of the lines and arcs in the composition lead the eye to this area, which is also the sharpest note of colour against the white paper. The plant itself is painted very simply, in keeping with the flat-pattern style of the work.

In the paintings on pages 87 and 88 I introduced fans as islands of white and colour. They lend themselves to interesting arrangements, and some offer potential for floral decoration, as do the fabrics.

The cyclamen plant is centrally placed in these particular works, but with much incident around it. It therefore becomes part of the design,

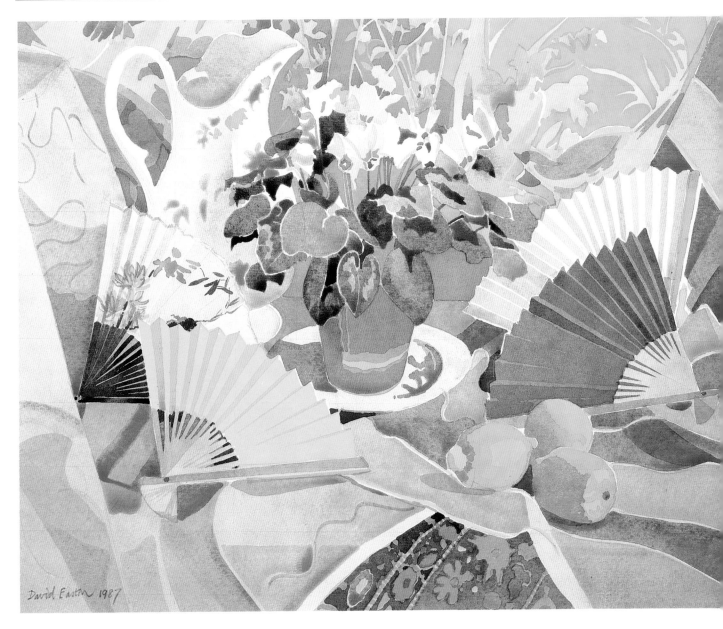

David Easton 1987

and not essentially the dominant subject. Many shapes break out of the painting on this page (of which a detail can be seen on page 43), hinting at a continuity.

The painting overleaf is more contained, with hints of a frame within the frame. The distribution of each colour throughout the rectangle is important and is therefore given careful consideration.

I have moved away from this strongly patterned style in more recent work, seeking a more atmospheric feel and sense of depth through closer colour-tone relationships. I continue, however, to be fascinated by explorations of flat pattern on the picture plane. These interests, both with the design on the flat surface, and in creating some sense of space, may seem to be in conflict, but that is all part of the engrossing business of painting.

Cyclamen and fans. *355 × 460 mm (14 × 18 in). A detail is shown on page 43*

(Overleaf) **Cyclamen and fans (2)**. *Watercolour, 280 × 205 mm (11 × 8 in)*

87

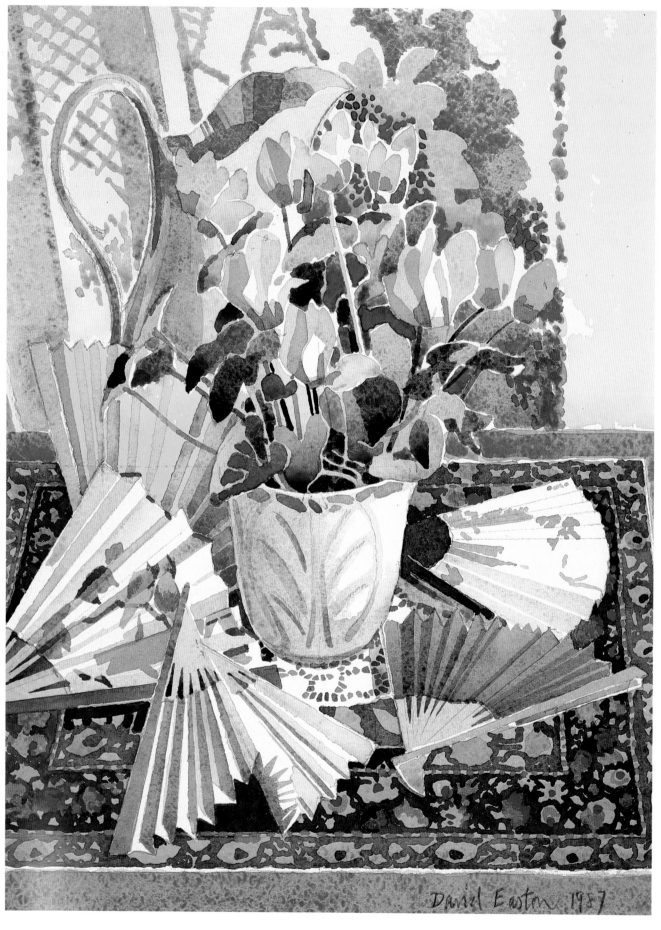

THEMES AND VARIATIONS (2)

STILL-LIFE CONTEXTS

The two square paintings on this page and overleaf were painted from the same basic subject with some re-arrangement in-between, and show a gentler style than that of the last few works. The colours intermingle to a greater extent in the settings, and the geometry is less overt. *Studio corner* has a predominantly analogous colour scheme. Only a few red/brown marks contrast with the yellow/green/blue. The edges of the fan, table and folds of fabric set up a series of slanting lines which offset the curving forms of containers, and arcs and lines continue the dialogue in the various patterns.

The colours of *Autumn still life* are more wide-ranging. Yellows play a major role here. They appear in many different contexts within the work, contrasting with their setting or forming closer associations. They are used in linear passages both under and over washes of the other colours. Some of these considerations can be borne in mind when setting up the group, but many will only become apparent as a work progresses.

I like to put flowers in a still-life context in order to create the potential for works which inhabit the whole of the rectangle. The flowerpiece on its own can be difficult to translate into a creative work: there are so many clichés and over-familiar

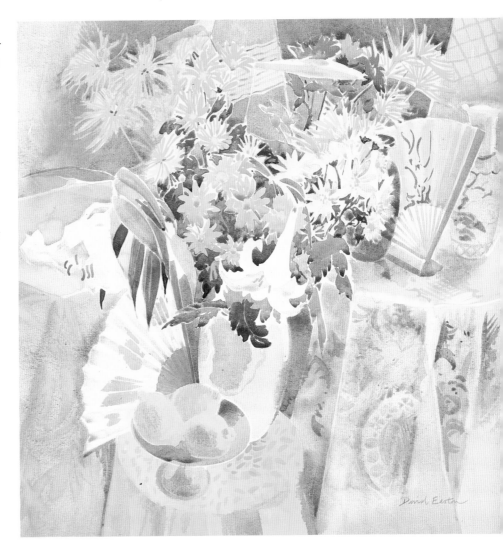

Studio corner. *Watercolour,*
540 × 540 mm (21 × 21 in)

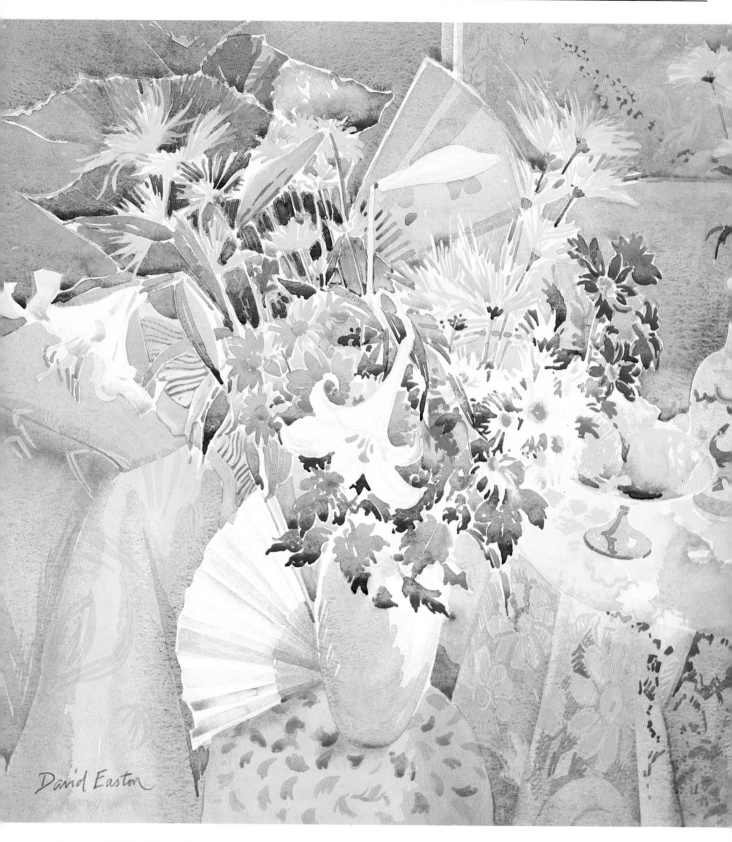

Autumn still life. *Watercolour,*
540 × 540 mm (21 × 21 in)

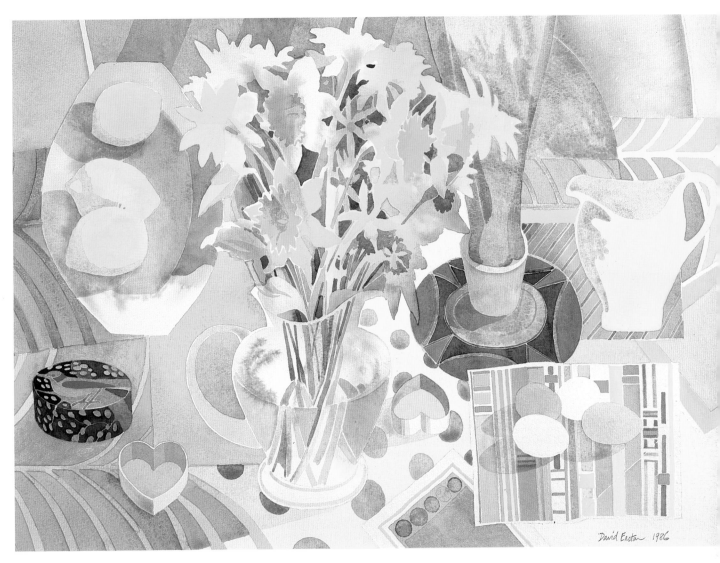

Spring collection. *Watercolour,
410 × 460 mm (16 × 18 in)*

placings, with the flowers invariably
occupying the top of the painting.
I would not encourage you to be
different for the sake of novelty, but I
do suggest that you seek a personal
vision. This arises from observation of
the subject, and from taking an open-
minded interest in the way other
painters have interpreted it.

Spring collection (above) exemplifies
another approach to picture-making.
There is no single viewpoint: the
work is a montage of objects,
influenced to some extent by collage.

TULIPS

Painted in the garden, and taking most of an April day, this picture was composed from at least four viewpoints. The method involves placing each shape in relation to the space remaining, until a satisfying grouping is achieved. The white *negative* areas are of equal importance, as discussed on page 56.

I felt happy about this work after placing the first three flowerheads and some leaves in promising positions. As usual, I had to keep in mind the colour and tone balance as well as the linear movements. From time to time I moved between two beds of tulips, looking for a shape and colour to carry the work forward. Later, in the studio, the only addition was an adjustment to tones around the leaves.

Most of the painting contains yellows: a combination of Aurora Yellow, Winsor Yellow, and Lemon Yellow Hue. Oranges and reds were put in while the yellows were moist, and sharper accents followed when these had dried. The leaves were based on a mixture of Cerulean Blue and Naples Yellow, along with other yellows and a touch of Alizarin Crimson. I also used a Viridian/ Alizarin mix, and there is Brown Madder Alizarin in a few of the darkest accents. The painting occupies a full sheet of 140 lb (300 gsm) Arches Not paper.

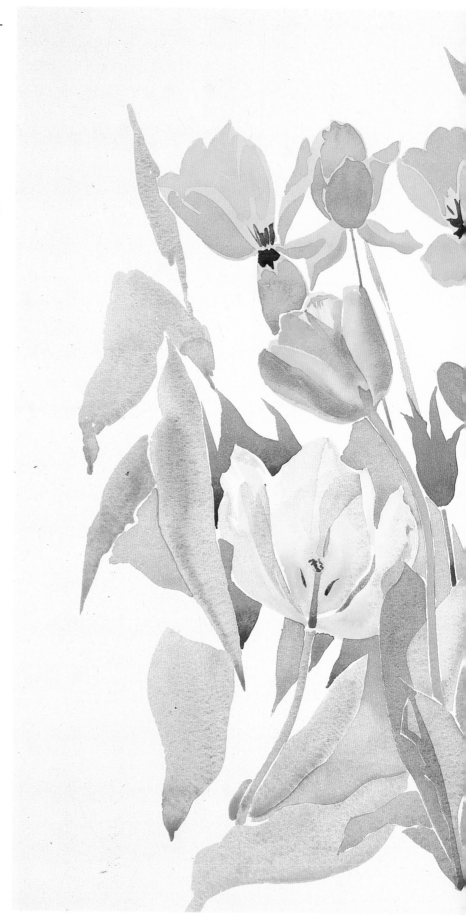

Tulips. *Watercolour, 510 × 760 mm (20 × 30 in)*

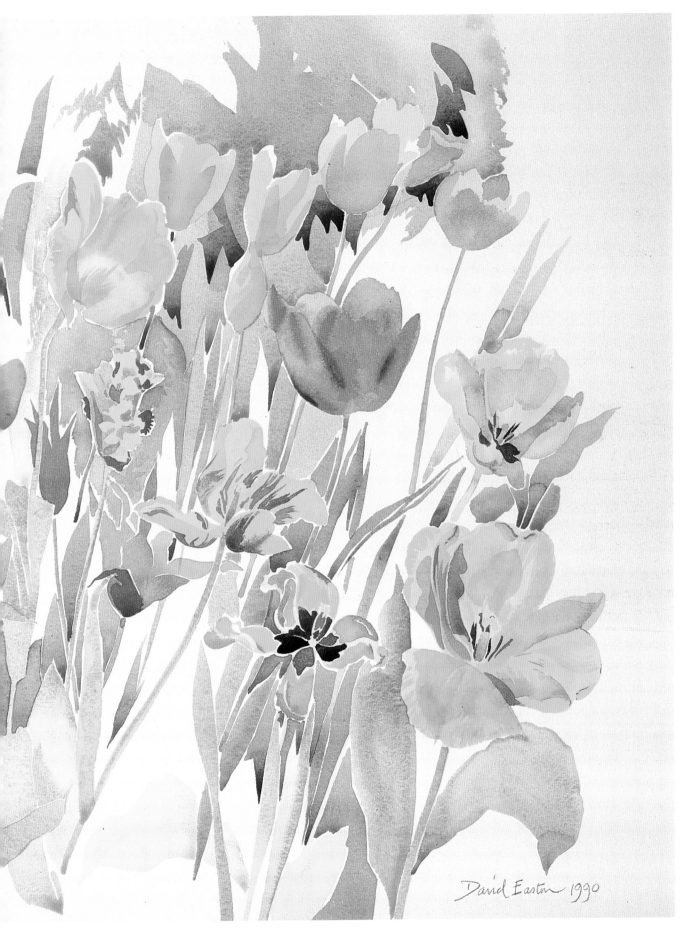

David Easton 1990

Tulip studies. *Watercolour and pencil,*
230 × 305 mm (9 × 12 in)

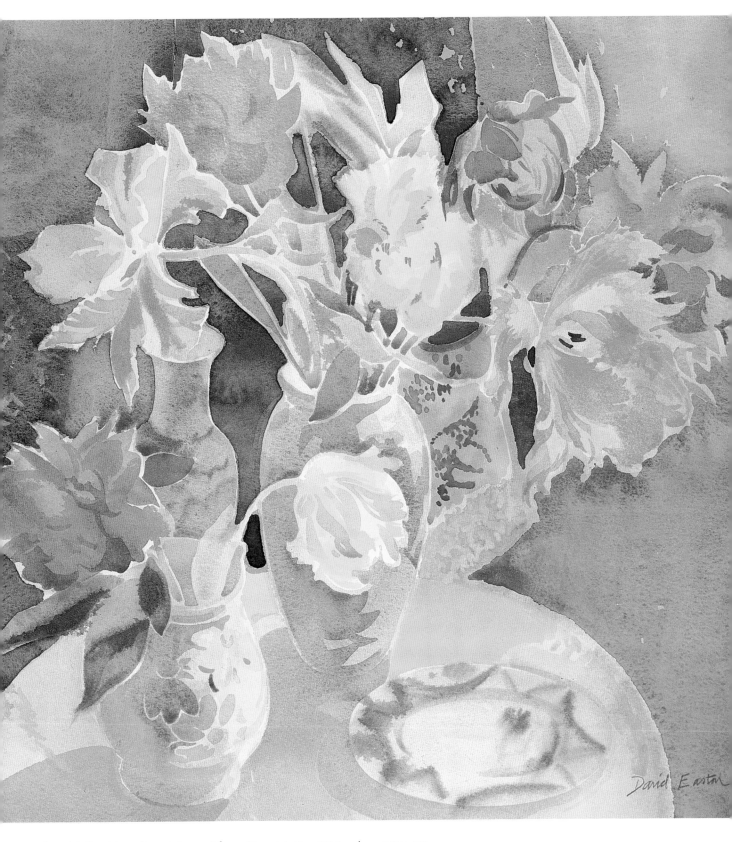

Parrot tulips (above) contains a rich set of colours. It is the sort of subject which I hesitate to tackle, because of the diversity and dangerous sweetness of the colours.

Parrot tulips. *Watercolour, 540 × 540 mm (21 × 21 in). A detail is shown on page 31*

Where all three primary colours are present, one of them has to be dominant. I used muted blues, and only cool reds, while yellows pervade most of the square. White paper is reserved here and there to give some relief, and to key some edges.

Tulip studies. *Pencil and oil pastel on grey paper, 410 × 560 mm (16 × 22 in)*

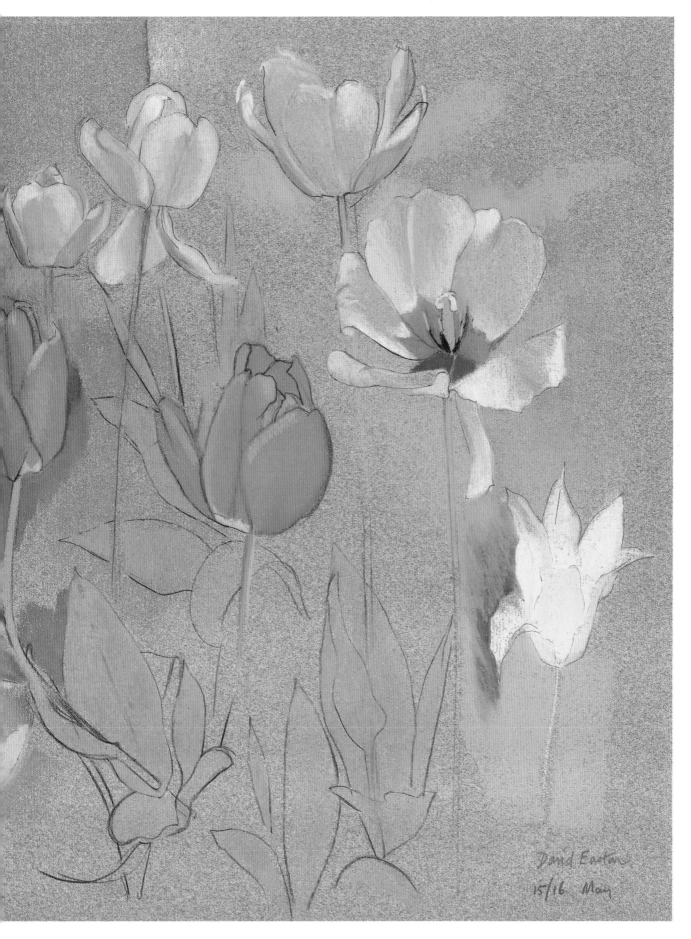

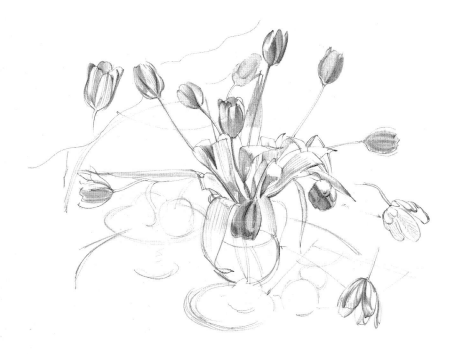

Tulip studies. *Pencil, 330 × 410 mm (13 × 16 in)*

Tulip studies. *Pencil and crayon, 255 × 355 mm (10 × 14 in)*

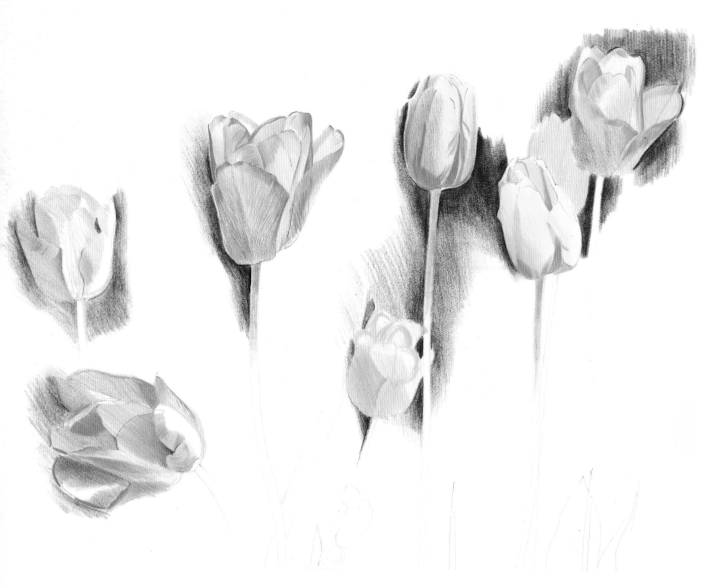

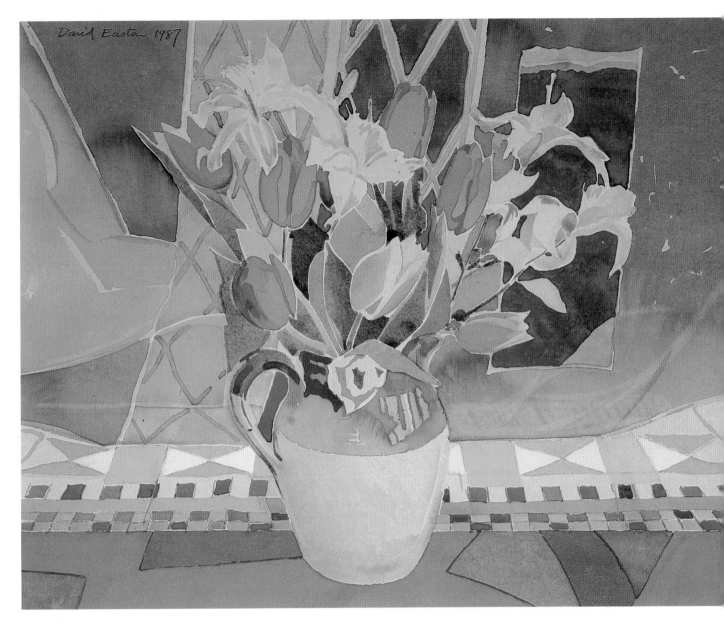

The painting above, entitled *Tulips in a jug*, is similar in spirit to the last two paintings in the poppy section (pages 76–7). This watercolour is painted on a buff-coloured De Wint paper, which is rough, and difficult to stretch. I push thumbtacks through the tape holding the edges, to prevent the paper springing away as it dries and stretches. The surprising thing about working on a tone such as this is that it can become acceptable as the lightest accent. This remained a totally transparent work, except for some of the orange and cream fabric patterns. The red of the flowers is balanced by similar colours in the fabrics at the base.

Tulips in a jug. *Watercolour on De Wint paper, 355 × 460 mm (14 × 18 in)*

IRISES

I find fresh interest in irises each year. The shapes are full of variety, and the colours can have exquisite subtlety or dramatic presence. Some of the many bearded varieties are establishing themselves in our garden, and the yellow flags have been around for many years. I like to make studies in the garden, but find it difficult to compose *in situ* because these flowers tend to stand above and apart from other subjects. Most of my paintings are therefore constructed in the studio, from sketches such as those shown here. *Pale mauve irises* on page 105 is an exception, as are the small paintings on pages 15 and 28.

The studies on these two pages are about shape, colour and tone. They are made directly with the brush, with the eye constantly aware of the negative shapes. I am sure that a more accurate evocation of the flowers is achieved than that which might begin with elaborate pencil work, as the characteristic petal shapes can only be made with a loaded brush. The

Iris studies. *Pencil and watercolour, 410 × 255 mm (16 × 10 in)*

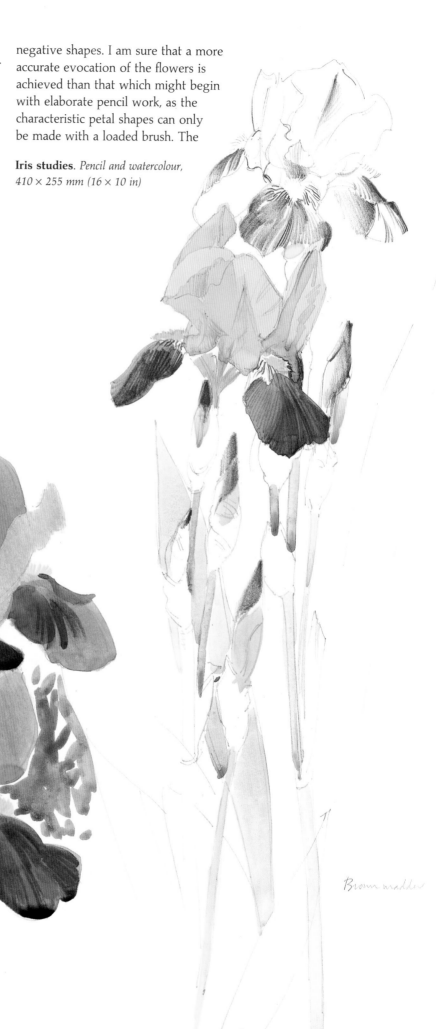

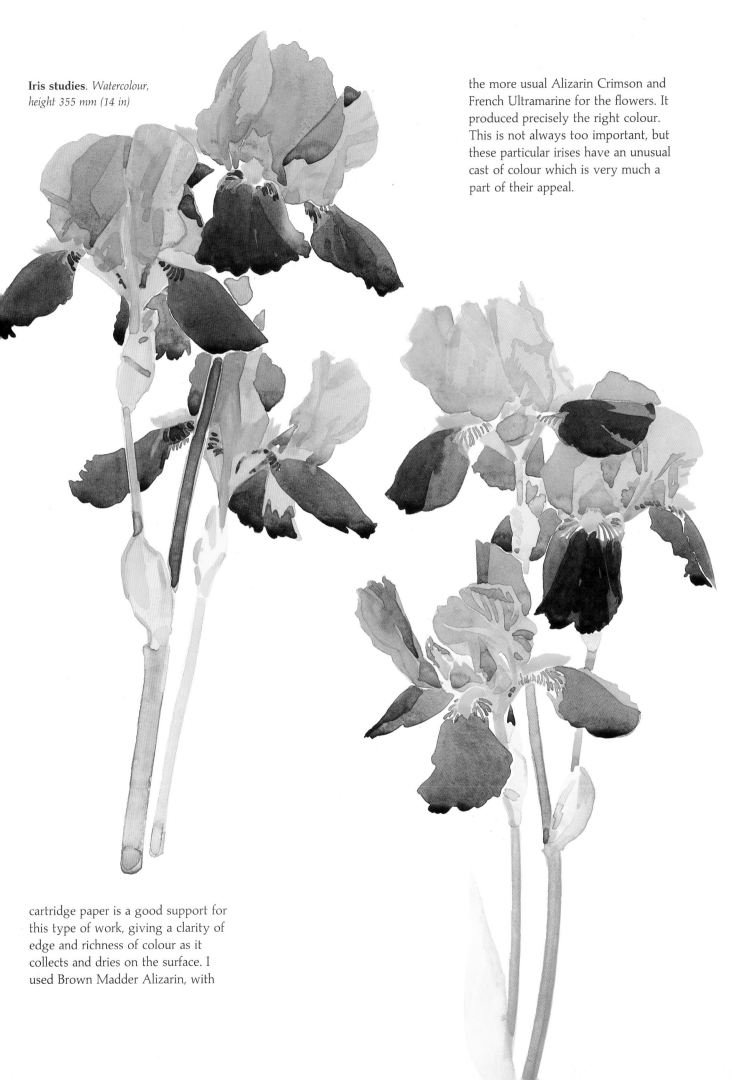

Iris studies. *Watercolour,*
height 355 mm (14 in)

the more usual Alizarin Crimson and
French Ultramarine for the flowers. It
produced precisely the right colour.
This is not always too important, but
these particular irises have an unusual
cast of colour which is very much a
part of their appeal.

cartridge paper is a good support for
this type of work, giving a clarity of
edge and richness of colour as it
collects and dries on the surface. I
used Brown Madder Alizarin, with

David Easton 1989

The pencil-and-watercolour drawing on the left formed a starting point for several paintings. *Pond with flags* (above) is an amalgam of the drawing with photographs and sketches of a lily pond. There is much overlaying of washes in this painting. The area occupied by flags has been washed and sponged out as a distinct shape, creating a strong division within the rectangle. The painting has become a design occupying the whole format in a tapestry of shapes and

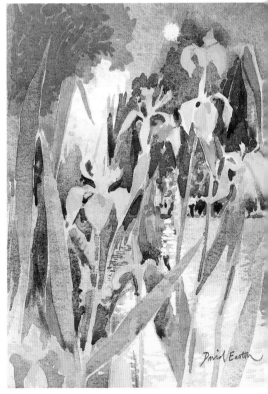

(Above) **Pond with flags**. *Watercolour, 380 × 610 mm (15 × 24 in)*

textures, and the spatial relationships are ambiguous.

The small painting on the right adopts much the same composition as the drawing, but places it in an imaginary setting. Gouache is used to make water textures between the stems.

(Left) **Yellow flags**. *Pencil and watercolour, 485 × 305 mm (19 × 12 in)*

(Right) **Yellow flags**. *Watercolour and gouache, 280 × 205 mm (11 × 8 in)*

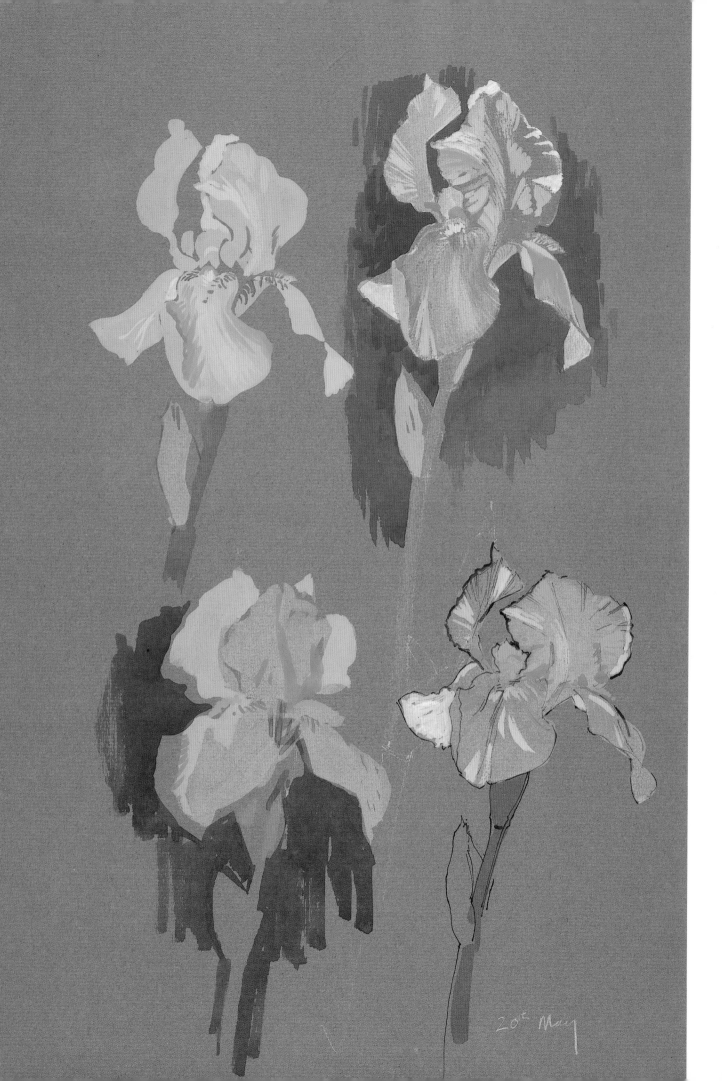

20ᵗʰ May

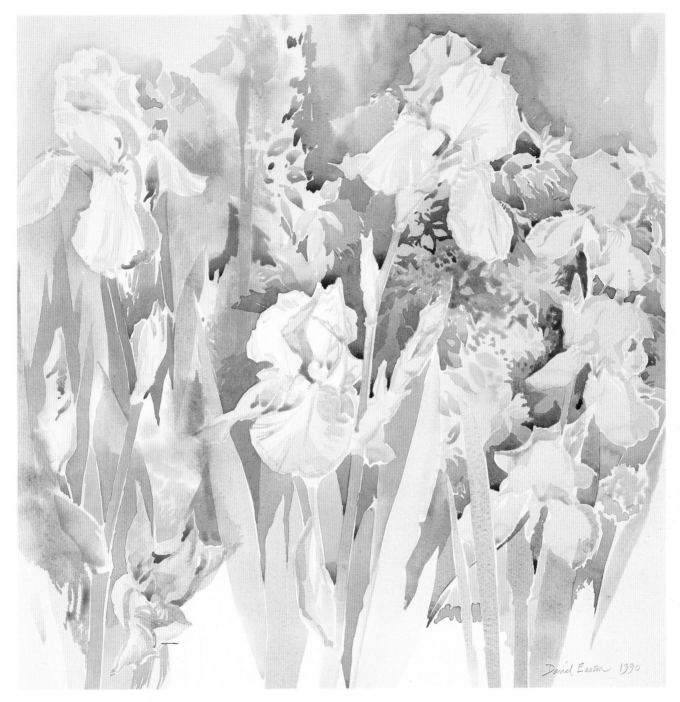

The studies in gouache on a mauve/grey paper (left) show the same flower from the same viewpoint. I often find it a rewarding exercise to carry out several studies in the quest to define the balance of petal forms which gives a flower its poise. It is often a matter of making what turn out to be progressively simpler drawings, as the essence of the form is revealed.

In contrast to these positive shapes placed on a tone, *Pale mauve irises* (above) involved painting negative shapes to reveal the flowers. This painting was produced in the garden, where I set my easel in a high position in order to paint standing up. Only a few passages of warm colour were added in the studio, to tune the work. Varied foliage from behind the flowers gives a change of scale and texture, and the lower part of the setting is simplified to allow the leaf and stem shapes to thrust upwards into the picture.

(Left) **Mauve iris studies**. *Pen, watercolour and gouache, 380 × 230 mm (15 × 9 in)*

Pale mauve irises. *Watercolour, 540 × 540 mm (21 × 21 in)*

Lily pond. *Composition sketch, watercolour, width 318 mm (12½ in)*

Yellow irises. *Composition sketch, watercolour, 460 × 355 mm (18 × 14 in)*

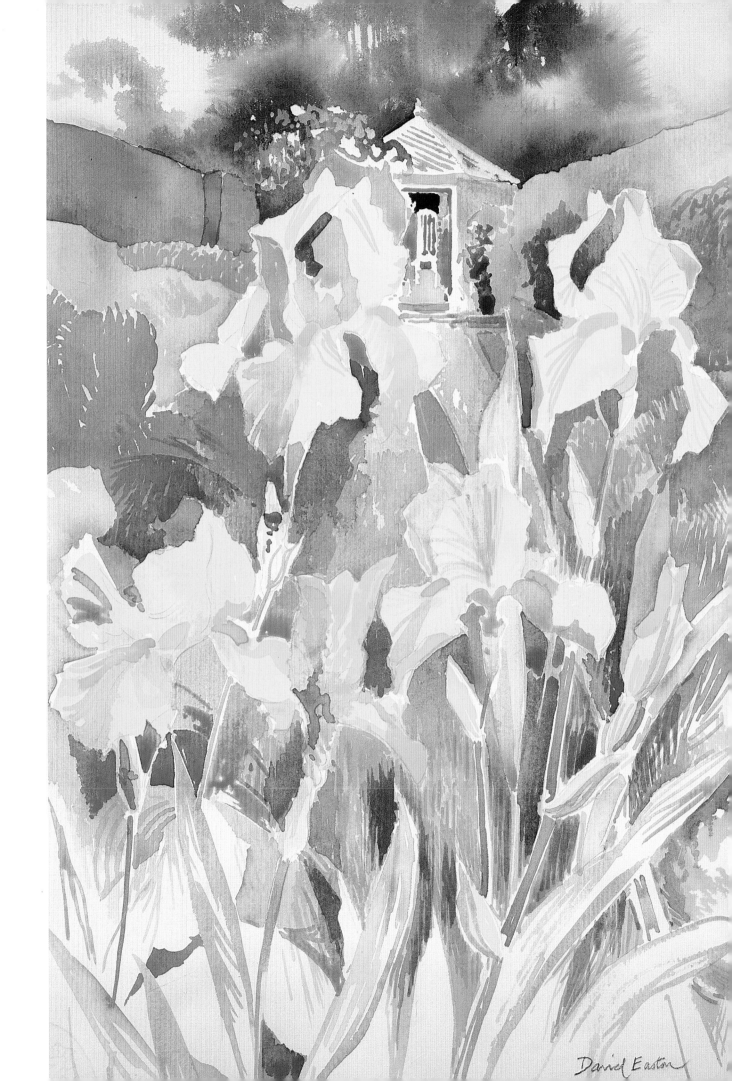

Daniel Easton

WHITE FLOWERS

This section is about painting white flowers in the traditional way, without recourse to the opaque painting methods shown earlier. White flowers are both interesting and challenging. The first thing to note is that white is very rare in nature: intrinsically white objects will always be seen in some shadow. The lightest values – such as petals in direct sunlight – will need to be reserved against delicate touches and washes of transparent colour.

Much of the work that follows consists of building away from these high-key passages. With landscape, you can often work from the distance to the foreground, but in flower painting you meet with many situations when you are working front-to-back. It is difficult to visualize the outcome, especially when the actual tonal relationships in the subject are changing.

The two paintings shown here began with a very light pencil scaffolding. I then began to brush-draw the flowers and light stems with yellows and pale blues. When using an outline to define a shape at this early stage, it is given a value that can be absorbed into later background shapes. The flowers are gradually formed with marks of deeper tonality, and things seen beyond are given strength and contrasting colour to throw the light blooms forward. *White flowers* was carefully arranged to contrast the rounded forms of pot, cup, plate, lamp and table with the lines of fans and the sharply-defined stems of carnations. Lace-fabric edges echo the petals. The table area is simply painted, allowing the paper to play a part, while small, sharp accents enliven the composition.

In *Spring flowers* the sensation of cool, early spring light was the subject, and is another example of working the setting around the flowers. The tulips combine subtly

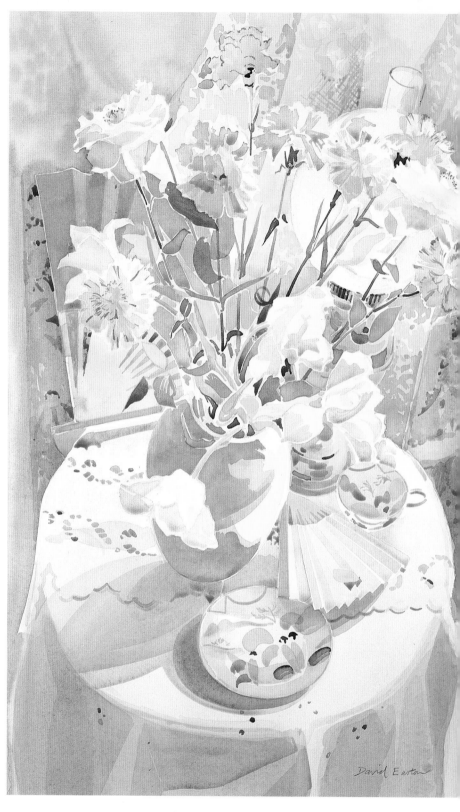

White flowers. *Watercolour, 585 × 355 mm (23 × 14 in)*

with the pattern of a fabric square, and small notes of pure colour add a sparkle to the quiet scheme.

Spring flowers. *Watercolour, 610 × 380 mm (24 × 15 in)*

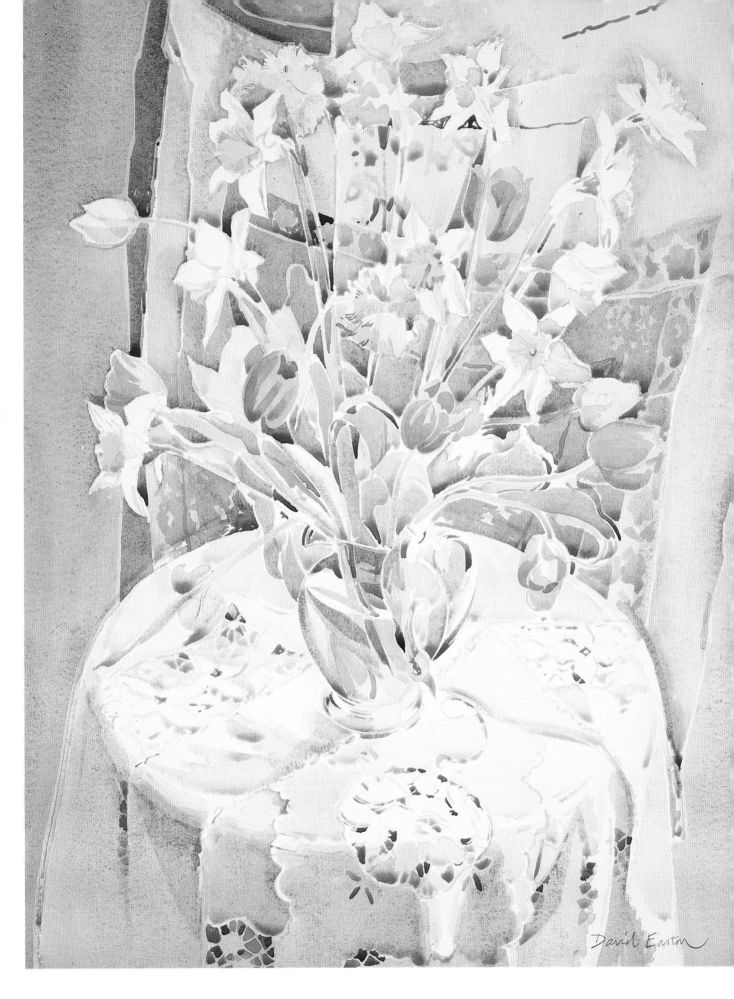

OBJECTIVE COLOUR STUDIES

These studies differ from most that I have made, in that they are attempts to capture the actual colours of a particular flower. This set of pansy studies on grey paper includes compositions, but is chiefly intended to get as close as possible to the hue and intensity of the colours.

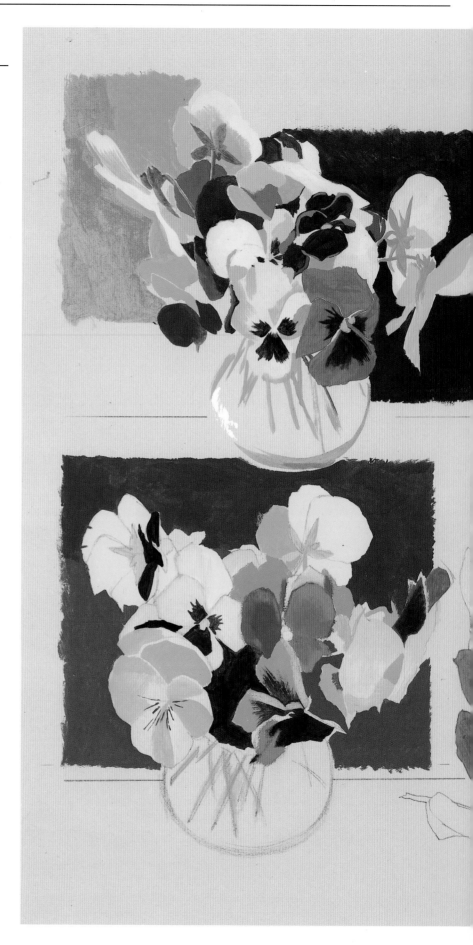

Pansies. *Mixed media, 355 × 535 mm (14 × 21 in)*

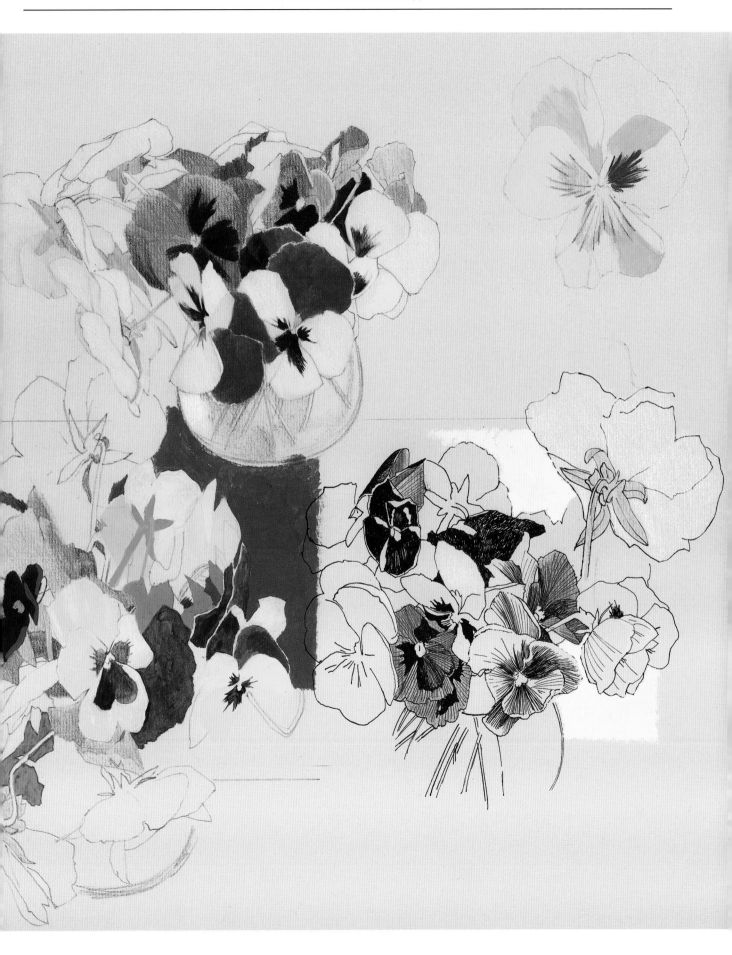

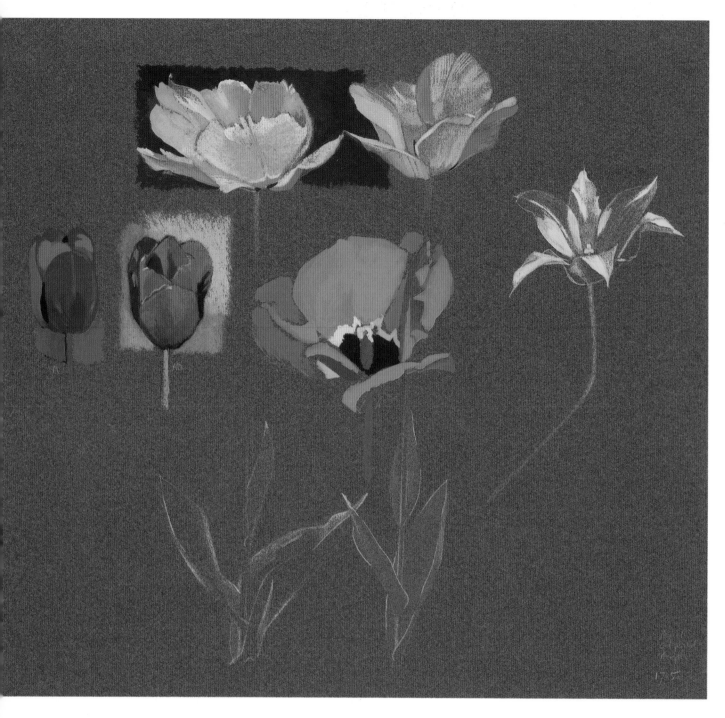

The tulip studies in various media (above) are almost solely concerned with colour.

Oil pastels, acrylics and pencil crayons have proved useful when a density of saturated colour is sought. There is much richness and colour intensity to be found in watercolour pigments, but other media can be helpful for these colour studies, because the results are more direct. Objective study of the colour to be

found in familiar subjects may lead to seeing them afresh.

The colour that you wish to analyse may not always be as rich and resonant as in these first examples. I have found that pencil crayons can be an excellent medium for exploring subtler colours, and the drawings can easily be translated into watercolour paintings. The process of construction in both media involves overlaying semi-transparent pigments

Tulip colour studies. *Mixed media on brown paper, 205 × 380 mm (8 × 15 in)*

with the paper showing through. The iris study opposite is in crayon over graphite pencil. It contains very different information from that given by brush drawings of the same subject on page 101.

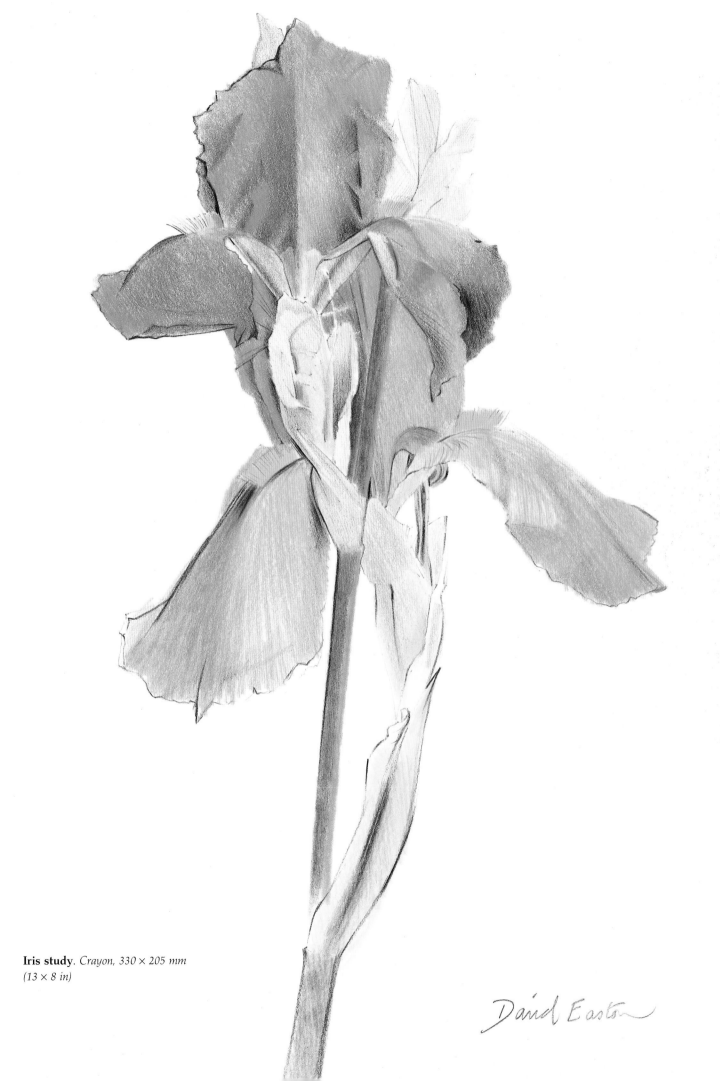

Iris study. *Crayon, 330 × 205 mm*
(13 × 8 in)

PAINTING AND PRESENTATION

WORKING SITUATIONS

Even a garden of modest size can offer a profusion of subject matter. The problem is where to start. A viewfinder can be very useful: a slide holder or a window from a card offcut will suffice. A refinement can be produced by sandwiching acetate between two card windows, and sub-dividing the transparent material by means of fine lines drawn with a technical drawing pen. You can then plot features of your subject by relating this grid to a light pencil grid on your paper. Subjects present themselves in a new way when you are able to mask off the distracting surroundings.

Whether you are working outside or in a studio, you should always try to face the subject directly, so that you are making eye movements rather than head movements when your gaze shifts between subject and painting. When blessed with sunshine, avoid looking into it, or letting it dazzle you as it rebounds from the paper. It is also necessary to be able to judge tone values.

Some people weigh themselves down with far too much kit. Everything that you can hope to achieve on location – whether in your own yard or further afield – can be carried out with a couple of brushes, a pencil, basic colours, water, a palette and some rags (easels and stools are a matter of your choice and comfort).

Large washes of colour are easier to manage in the studio. A style which involves smaller touches and linear work is appropriate for location work.

Tinted papers are worth considering: they are especially helpful in unifying a sketch when painting a complex area of foliage. Sketches which exemplify these last two points are shown on pages 14 and 15.

For painting flowers at home you will need a space which offers peace and quiet, and a good natural light. A window giving light to the side of, and slightly behind, the subject is ideal. It allows light to shine through some of the petals and leaves, revealing form at the same time. You will also need some flexibility to rearrange your subject matter and the setting. I find the most useful props are tables and containers of different heights, with a range of fabrics to create colour and tone contexts. Containers can be very ordinary, simple shapes: plain-white glazed or glass vases are always useful.

When you start a painting, whether or not you have made preliminary sketches, spend some moments just looking at the subject. Identify the basic colour scheme, and look for sub-groupings or areas that can be blocked together in colour or tone. Look also for linear flows and rhythms, and for focal areas. This time spent sorting out a way into the work is very worthwhile: it can give you a positive objective, or at least a

confident first step on the way.

A flower painter has to learn to accept change, both in the light and the plant material, and this becomes less of a problem if you can adopt a way of looking and painting that is flexible. If you try to pin things down too tightly – especially early in the work – you will find changes very frustrating.

I have suggested elsewhere that only two or three colours should be on the palette at the beginning. I often start with generous amounts of my chosen colours pre-mixed in the palette. This enables me to work freely for a while, without needing to work up more pigment or squeeze out tubes. Anything that facilitates concentration is to be welcomed.

THE PAINTER'S VISION

For most artists, painting is not an even, gradual progression towards some imagined standard. It is a journey with occasional insights and

Pelargonium and urn. *Watercolour, 355 × 305 mm (18 × 12 in), by Shirley Easton. My wife shares my interest in painting flower subjects in water-based media, and our garden has been a source of inspiration as the seasons pass. In this painting the urn cuts into the profusion of colour to make a bold asymmetrical composition*

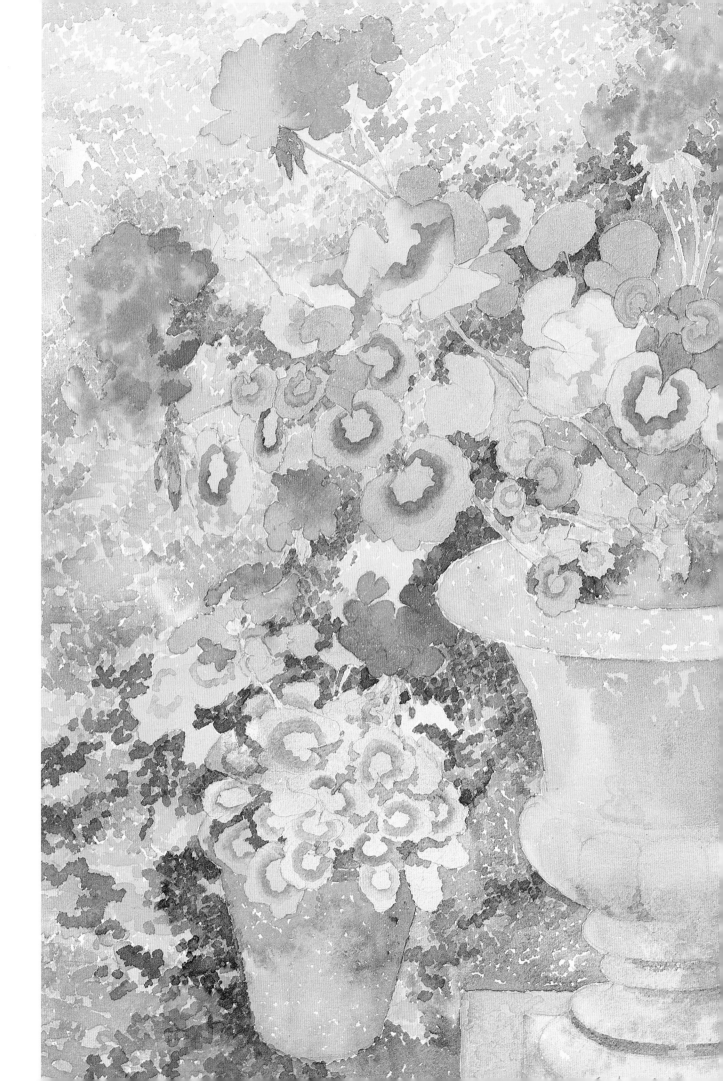

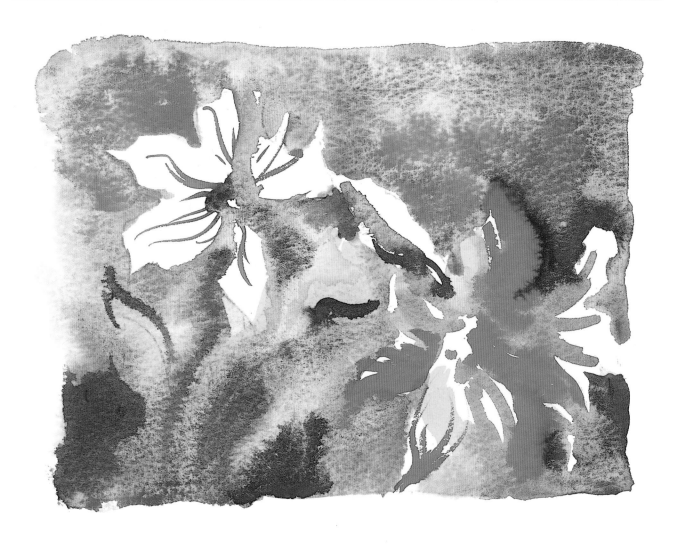

Wet-in-wet sketch, after Emile Nolde

milestones, and with long plateaux in-between. Painting is not about acquiring a skill, which you can then use to produce works in convoy, each as predictable as the one before. Beginners may well try their hand at landscape, still life, flowers, figures, portraits, pets, transport, buildings and so on, but you will not see a mature painter casting around in all directions for subject matter. When a painter values vision and pictorial composition above technique, each subject will have limitless potential.

Looking at paintings

As a writer reads, so a painter must be aware of the works of others.

Watercolours are comparatively rare in major international shows, but they are worth seeking out. Some museums and art galleries keep their works-on-paper tucked away from view for much of the time, but you can ask to see them.

When visiting an exhibition I do so with keen anticipation, hoping to find some works that delight the eye, and perhaps to learn something. While it is fascinating to analyse the methods that have been employed, I gain more from pondering on what prompted the painter to present the subject in a particular way, and what processes of seeing have been involved. The best watercolour paintings are not always by watercolour specialists, but by painters who use this medium for just a part of their output.

FRAMING AND EXHIBITING YOUR WORK

When completed, some of your work will need to be mounted and framed under glass. A reliable framer is a treasure. You need good workmanship, and advice about the quality of the materials. Deal directly with your framer if possible.

Mounts (matts)

The best materials are acid-free boards, both for the window mounts and as a buffer between the work and the hardboard backing. Do not cramp your work with narrow borders: a watercolour needs breathing space. Equal borders do not work, as an optical illusion makes the work look

uncomfortably low in the space. You therefore need to allow more depth at the bottom, and less at the top. Double-window mounts look better than wash-line mounts on some contemporary work.

Things to avoid:

(a) any wording on the front of the mount or frame.
(b) work creeping over from the paper on to the mount.
(c) pieces cut out of the mount to accommodate an irregular design.
(d) only your name and the date should be written on the front of the work.
(e) letters after the name and copyright symbols are an unnecessary pretension.

Advice for those submitting works to open exhibitions:

(f) read all the forms carefully, and comply with the conditions.
(g) never submit work with screw-eyes or other projections from the frame.
(h) choose robust frames when storage and handling are involved, avoiding mouldings with colours overlaid on gesso. Plain wood – stained or natural – is less likely to incur damage.
(i) protect the corners with bubble-pack or corrugated card.
(j) keep records of all your works, including dates, dimensions, price, and venues of the exhibitions in which each has been shown. Otherwise it can get confusing if you become prolific!

COLOUR AND MATERIALS

THE COLOUR WHEEL AND PALETTE

The pigments used for most paintings in this book are set out in this diagram, arranged in relation to the theoretical model known as the *colour wheel*. You will see that many of these colours are clustered around the primaries, and, furnished with reds, yellows and blues you can mix almost any colour. I include Winsor Violet, Cadmium Orange and a couple of greens in the palette, but use them infrequently. I do find Burnt Sienna and Raw Sienna valuable, partly because they associate with blues and mixed purples respectively.

I would strongly recommend that you mix greys and browns from primary and secondary colours whenever you can. Such mixes have more character, as the proportion of each constituent varies.

From time to time you may need to buy special colours in order to make a very specific flower colour. Some of these unusual colours have fugitive (or unstable) properties, so it is wise to check with the makers' lists to establish the degree of permanence.

COLOUR SCHEMES

It does not always pay to be too scheming about colour. There *are* principles worth learning and applying, as long as they do not

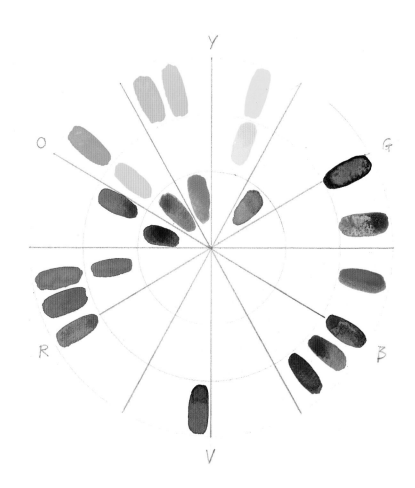

become hard-and-fast rules, but you need to be responsive to the subject, and to your instincts.

The colour composition of any painting is likely to be predominantly either warm or cold, and it is a good general strategy to include some contrasting colour from the opposite polarity as a foil to the main family of colours. The relative proportion of colours, in terms of the areas they occupy in the work, is as much a part

Pigments in relation to the colour wheel. Reading clockwise from Y: Winsor Yellow and Lemon Yellow Hue; Brown Pink; Hooker's Green Light; Viridian; Cerulean Blue; Cyanine Blue; Cobalt Blue; French Ultramarine; Winsor Violet; Magenta; Alizarin Crimson; Cadmium Red and Cadmium Red Deep; Burnt Sienna and Brown Madder Alizarin; Cadmium Orange; Naples Yellow; Raw Sienna; Cadmium Yellow; Aurora Yellow and Yellow Ochre

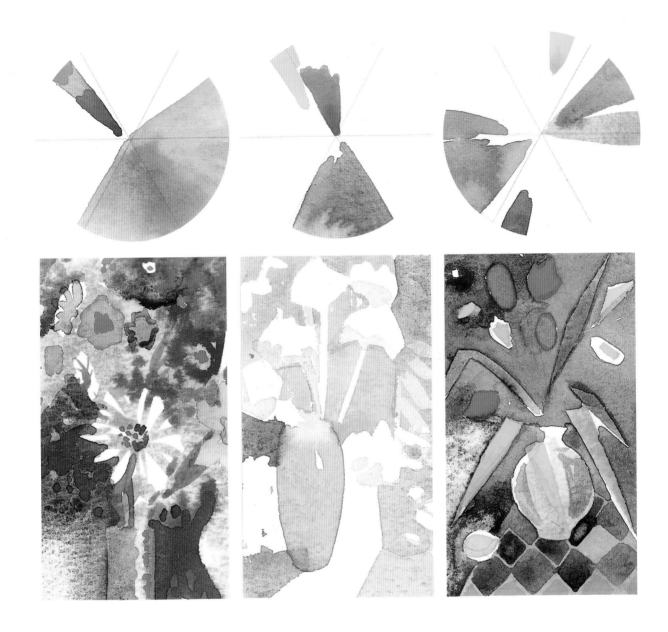

Three possible colour schemes

of the scheme as the choice of pigments.

It takes a lot of experience to handle a wide-ranging palette, and I would advise you to start with just two or three colours, even when the subject is very colourful. Try to identify the primary components, and aim to make most of the secondary and tertiary colours from these. This may involve pre-mixing, as well as mixing on the paper itself by over-laying wet-on-dry applications of pure colour.

This is where a colour comp-ositional sketch may prove to be invaluable. Of the countless permutations, I have shown three schemes above. On the left is an analogous scheme: cold colours, together in the colour wheel, with a touch of contrasting warmth. In the centre is a scheme in which the white paper plays a vital part in the composition, and on the right, islands of primary and secondary colour are enhanced by neutrals mixed from the same pigments.

USING COMPLEMENTARY COLOURS

Colours which are approximately opposites on the colour wheel make very useful pairings. They complement and enhance each other, especially when they are placed together at a close tone value. They also represent a warm/cold contrast in every case.

When mixed together, they produce neutral greys and browns when the proportion of each is in balance. One of the most frequent usages of a complementary colour is to modify, darken in tone, or very slightly neutralize its partner. An example of this is when a blue is softened by the addition of a touch of orange. Burnt Sienna, which is an orange/brown pigment, will effect a similar change in blues.

The small squares on this page each show one result of mixing a pair of complementary colours to a point of balance. The closer the pair to a true opposite, the more neutral the colour will be. Taking blue/orange as an example again, you will get a more distinct grey when you try a red-orange with Cerulean Blue. Alternatively, a greenish colour is produced by combining yellow-orange and Cerulean Blue, because both are on the yellow side of their family of colour. You will doubtless draw similar conclusions about other mixes shown here.

Read across the page from the squares to see a continuum of colour produced by the pairings. These were painted by wetting the long rectangles with clean water, and introducing the colours at opposite ends. They represent only a fraction of the sets you could try.

(Right) Testing complementary mixes

(Opposite page) Colours produced by the pairing of complementary colours

Winsor Violet – Yellow Ochre

Winsor Violet – Winsor Yellow

French Ultramarine – Burnt Sienna

Cerulean Blue – Cadmium Orange

Viridian Green – Alizarin Crimson

Viridian Green – Cadmium Red

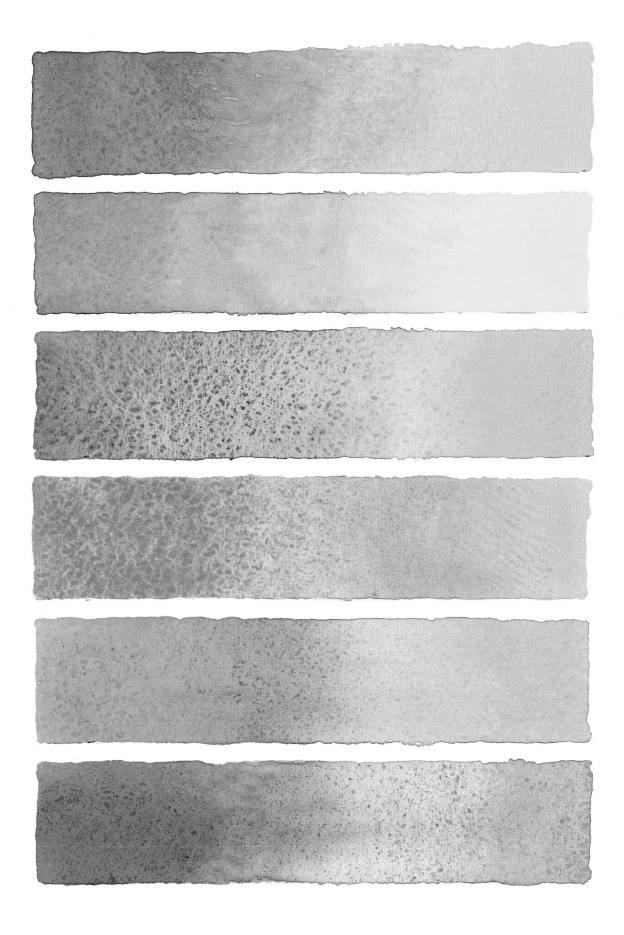

COLOUR MIXING

The swatches opposite, with the small grouping of blues laid both over and under the yellows, are an example of the process described below in the section on transparency. This is an unscientific exercise, and is only shown as a rudimentary idea. I often find that useful information comes through when I have a structure to work around, but allow instinct to take over.

PAINTS

Watercolours come in two forms: cakes and tubes. The cakes (often known as pans) are obtainable in artist's or student's quality. When you wish to use a box of pans, it is advisable to choose the artist's range from one of the leading makers. These moist colours respond quickly to the brush, yielding a satisfying amount of pigment. Pans of student's quality may prove hard to work up, and tend to produce disappointingly thin washes. Tube colours are especially useful for large-scale work.

When setting up with colours, you might consider some of the starter sets. They *may* be good value, but avoid those which include too many earth colours, along with black, Chinese white and perhaps a brush or two. This is false economy. You are unlikely to need black; some of the earth colours are expendable; and you should choose all your brushes with care.

I would recommend that you buy a selection of artist's-quality tubes and a palette, and, when you have acquainted yourself with these, decide on the type and size of box that will suit your purposes.

Alternatively, you may prefer to get an empty box and fit it to your own requirements. The following colours give a fair coverage of the spectrum, as well as plenty of scope for learning about colour mixing: Winsor Yellow (a rich lemon), Cadmium Yellow (or Aurora Yellow), Alizarin Crimson, Cadmium Red, Cerulean Blue and French Ultramarine.

The following would be very useful additions to the above, if funds permit: Raw Sienna or Yellow Ochre, Burnt Sienna, Magenta, Cobalt Blue and Viridian.

The most important attributes of colour pigments are: transparency and opacity, granulation, staining power, and permanence. Transparency and opacity are parts of an artist's armoury, and you need to find out how your pigments behave in this respect in order to get the most out of them.

Transparency

Most colours are transparent when diluted with water. That is to say, they allow the white of the paper to shine through. This quality is perhaps the most important for an artist to understand and exploit in order to produce good watercolours. The order in which colours can be built up – by means of a succession of washes or marks, each laid over dry colour – is well worth exploring.

For example, lay a small swatch of a yellow, and a swatch of blue alongside. Allow both to dry before laying a fresh wash of each partly over the other. You will soon see, when they have dried, that there is a significant difference in the way the washes have taken, and in the resultant greens.

The advantage of working in this way is that there is an element of *visual* mixing involved, because the eye sees not only green, but the yellow and blue in their own right. For comparison, you can paint a green which you have pre-mixed on the palette from the same yellow and blue. Try this with various strengths of colour, and with different combinations of colours.

Opacity

This offers a contrast where the substance of the subject may call for a density of texture. Some pigments are comparatively opaque, and greater opacity can be attained by adding white. This will also make colours cooler. It should be noted that the whole character of a watercolour painting can be changed by the use of opaque passages. This is not always desirable, as the uniqueness of watercolour resides in the fluid application of transparent colour.

Colour swatches

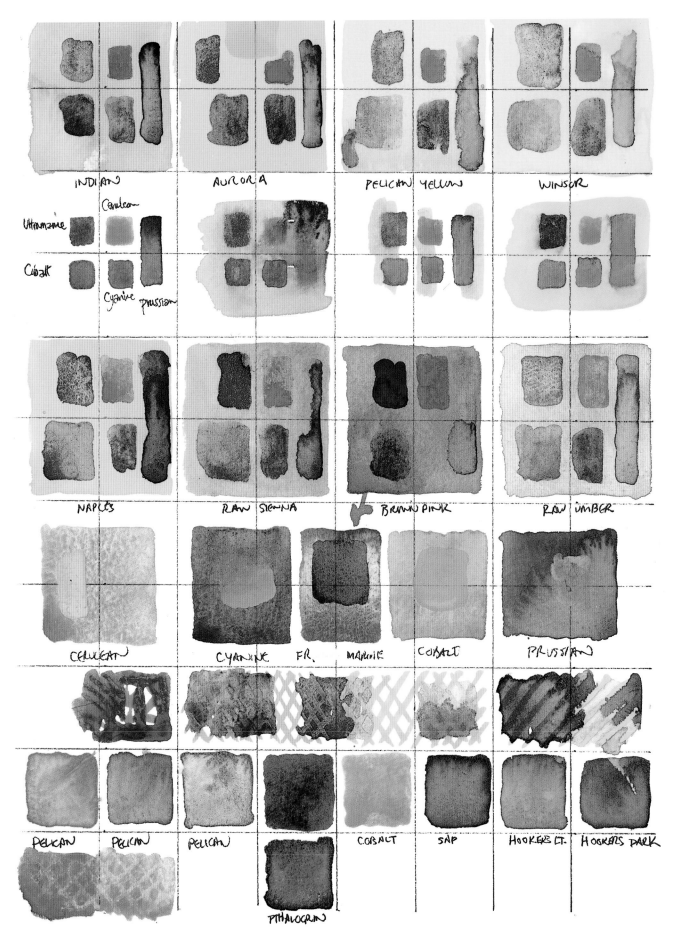

INDIAN AURORA PELICAN YELLOW WINSOR

Ultramarine Cerulean

Cobalt Cyanine Prussian

NAPLES RAW SIENNA BROWN PINK RAW UMBER

CERULEAN CYANINE FR. MARINE COBALT PRUSSIAN

PELICAN PELICAN PELICAN COBALT SAP HOOKERS LT. HOOKERS DARK

PTHALOGRIN

123

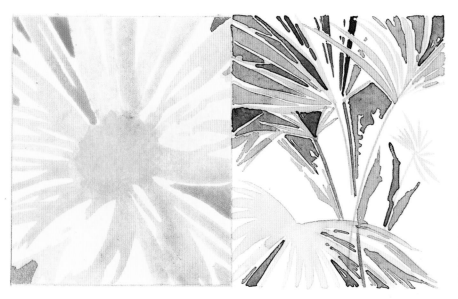
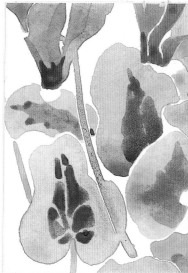

Granulation

This is the visible separation of particles of pigment on the paper, and it varies considerably. Of the colours on my list, Cerulean Blue, French Ultramarine, Viridian, Alizarin Crimson and Burnt Sienna have this characteristic to the most marked degree. It becomes more evident in certain mixes, and is much more significant when you are working on rough papers where the particles lodge in the crevices. You will need to experiment in order to gain control of this element in your paintings, which can contribute to the textural interest of your work.

Staining power

This can easily be assessed. Simply paint small swatches of each of your colours on a small sheet of paper, and wash the whole sheet under a tap. Try the process twice, washing off before the colours dry out and, on another sheet, after they have dried. The staining colours will be very evident.

It is wise to consider staining properties when embarking on work which may involve lifting- or washing-out techniques. You can either avoid the staining pigments, or make positive use of them to obtain desired effects.

Permanence

Most of the pigments you are likely to use will be relatively reliable in this respect, but it is wise to consult the maker's list if in doubt. Note that watercolour paintings should never be hung in direct sunlight.

PAPERS

The usual support for watercolour paintings is the paper or board made expressly for the purpose. It comes in loose sheets (560 × 760 mm or 22 × 30 ins being the most usual size), and is also available in the form of books (spiral- or cloth-bound) and on blocks with the edges gummed. Loose sheets are the most economical form, and blocks the most expensive.

There are three types of surface: *rough, hot-pressed* and *Not*. The latter (also known as *cold-pressed*) is by far the most widely used. It has a *tooth*, or slightly textured surface, which enables washes to adhere to the paper in a consistent manner. Rough papers suit a more open and vigorous style, and give more emphasis to any grainy effects. Hot-pressed (HP) papers are smooth, so that every brushmark tends to show, although great subtlety and delicacy of wash is possible on these close-grained papers. The less absorbent types of cartridge paper are also worth trying, especially for line-and-wash work.

Within the three watercolour surfaces you will find a range of textures, some of which can be rather intrusive. It would be sensible to try a few samples in order to select those that suit your taste and needs.

Watercolour papers are usually white, but there is white and white! If you compare a clutch of papers from half-a-dozen different mills, you will find a surprising range of whiteness from cream to blue-white. This can have a bearing on the feel of the work. Tinted watercolour papers are also available. They make an interesting change, as do some of the tougher pastel papers. Not all these

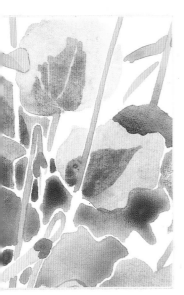
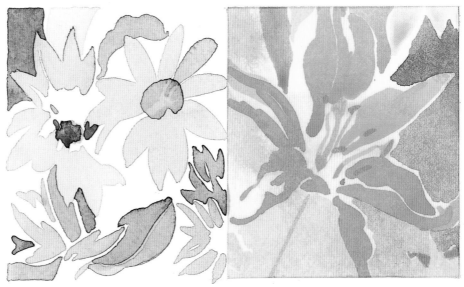

products are colour-fast, nor indeed are all the mount boards (matts), so care is called for in their choice, storage and use.

BRUSHES

You do not need to buy a fistful of brushes: two or three sables around sizes 1, 4 and 7 are my preference, as these pointed brushes give maximum control. I would add a Whistler Oxette, with a thin chisel end, and a broad one-stroke oxhair brush. A large Chinese brush completes the set. This latter item is a great asset, holding copious amounts of water and giving a lovely variety of mark.

This type of brush takes a little time to soften and seems to improve with age. On page 21 is a set of marks and textures made with these brushes, and a selection of brush-drawn marks on different surfaces is shown above.

It really does pay to look after your brushes. Cleaning them with fresh water, and shaping them gently with a soft rag, is a quick and easy task. The only other things to remember are not to stand them on their points, especially in water (where they will take on a permanent wave), and not to box them up without air when they are damp. If you follow this procedure every time you paint, your brushes will give you years of good service.

A selection of brush-drawn marks on hot-pressed and Not papers

INDEX

Acrylics 76–7, 112
Amaryllis *32, 57*
Autumn 60, *61, 62–5*

Botanical art 7, 56
Brush-drawing 10, 14–24, 45, 60, 63, 68, 72–3, 100–1, 108, *125*
Brushes 21, 125

Carnations *44–5*
Cézanne, Paul 10
Chrysanthemums *2–3, 35*, 60–3, *89, 90*
Colour 118–25
 analogous 65, 89, 119
 complementary 37, 43, 70, 83–5, 120, *120, 121*
 composition 85, 118–9
 contrast 20, 31, 32, 67, 108, 120
 limited 85, 114, 119
 mixing 122, *123*
 primary 23, 96, 118, 119
 saturated 60, 74, 112
 schemes 118–9, *119*
 temperature 21, 32, 65, 83, 84–5, 105, 118, 120
 wheel 32, 118, *118*
Composition *38*, 51, 52–5, *52*, 54–5, 60, 81, 86, 89–91, 118, 119
Crayons (pencil) 10, *50*, 71, 98, 112, *113*
Cyclamen *8*, 17, 23, 42, *43*, 62, 83–8

Drawing 44–5, *46–7*, 47–9, 51

Exhibiting 116–7

Fans *86–8*
Fluid colour 10, 15, 21, 29, 62
Foliage 40–3, 70, 105
Framing 116–7
Free style 37–9, 53–5

Garden settings 43, 76, 80, 92, 100, 105, 114

Gouache *68*, 103, *103, 104*
Granulation 21, 124

'Handwriting' 7, 14
Hellebores *50*
Hydrangeas *20*, 78–82

Implication 47–8, 53
Inks 12
Inspiration 7, 8, 59, 114–6
Inula *front cover, 25*
Irises 9, *10*, 15, *28, 29*, 48, 72–5, 100–5, *107, 113*

Lilies *2–3*, 9, *13*, 36, 46–7, 51, 54
Limited palette 32, 59, 114
Line and wash 9, 10–12, *11–13*

Magnolia *9, 30*, 35, *36*
Materials 114
Movement 47–9, 70

Nasturtiums *front cover, 25*
Negative shapes 56, *56–8*, 92–3, 105
Nolde, Emile 25, *116*

Objective studies 110, *110–1*, 112, *112, 113*
Observation 15, 91
Opaque colours 31, 34–7, *34, 35, 36*, 63, *63–4*, 68, *68*, 76, *76, 77*, 103, *103, 104*, 122
Orchids *58*

Paints and pigments 118–22
 granulation 63, 124
 opacity 65, 122
 permanence 124
 staining power 63, 124
 transparency 122
Pansies *110–1*
Papers 59, 124–5
 Arches *46–7*, 47, 92, *92–3*

cartridge 17, *17*, 19, 51, 124
De Wint 99, *99*
Fabriano 26, *26*, 36, 60, 63, 64, 65, *65, 107*
hot-pressed *19*, 46–7, 68, *68*, 124
Not (cold-pressed) 67, *67*, 70, *70*, 80, 81, *92–3*, 124
pastel and coloured 15, 17, 26, *28*, 36, 51, 60, 63, 64, 96–7, *104*, 107, *110–13*, 124–5
rough *20*, 124
stretching 74, 99
Pastels *49*, 51, 59, 96–7, 112, *112*
Pattern 21, 42–3, 76, *76*, 85–7, 89
Pelargoniums 18–19, 40–1, 115
Pen and ink 10–12, *13*, 45, 51
Pencil 10, 44–5, *44*, 46–7, *47–9, 49–50*, 51, *51*, 94, 98, 108
Picture plane 23, 53, 64, 79, 85, 87, 91
Poppies *6, 14, 16, 27, 29, 34, 38*, 49, *52*, 66–77, *back cover*

Shape 15, 21, 23, 29, 43, 55, 56, *56*, 72, 76, 85, 87, 100
Sketchbooks 51, 60, 67
Space 53, 103
Still-life settings 89–91, *89–91*

Techniques 8–31
Texture 20–3, 60, 68, *68*, 70, *70*, 80, 81, 124
Tone values 9, 12, 21, 43, 60, 72, 84–5, 87, 92, 99, 100, 108, 120
Transparency 7, 8, 17, 99, *99*, 108, 122
Tulips *1, 26*, 31, 55, 92–9, *109*, 112

Viewfinders 43, 114

Waterlilies *103, 106*
Wet-in-wet 25–6, 29, 43, 74, 79, 84–5
White flowers *1*, 108–9
Working situations 114